# Northwest Originals

Oregon Women
and
Their Art

*Special thanks to*

## Pacific Power & Light

*for assistance in publication*

Library of Congress
Catalog Card Number: 89-81566

1989
© by InUNISON Publications, Inc.
Portland, Oregon
ISBN 0-9624305-0-1

## Writers

Lois Allan
Melissa Fisher
Ellen Nichols
Melissa Lowry
Jean Fuller Anderson
Sharon M. Wood
Paula Hartwig
Jean Kempe-Ware
Dorothy Thornton
Joleen Colombo
Gen Sage

## Photographers

David Browne
Charlie Borland
Cathy Cheney
Dorothy Thornton
Tim Hendrix
Helga Motley
Melissa Fisher
Wyn Berry
Ray Buonanno
Cliff Coles
Ruth Dennis Grover
Richard Stefani

## Editor

Ellen Nichols

## Technical Editor

Ruhama Organ

## Graphic Designer

Didra Carter-Hendrix

## Preface

It has been a treat for those of us involved in the creation of this book to meet, interview and photograph the women featured here. Professional artists all, representing a broad spectrum of creative expression, they proffer their individual visions, their inner souls.

Women, it often seems, regard their art more intimately than men, with a particularly female perspective. They often mention a creative spirituality, perceptions of common universal qualities. All talked of art as an integral part of their lives — as work they *must* do — inseparable from their social and personal experiences. Art is often the balance and harmony within their lives.

The female experience of our cultures is to nurture, to procreate, to persevere. Their attitude of caring — for environment, for society, for personal relationships — is the feminine nurturing experience. When one sees and hears those same experiences played out through a seemingly diverse selection of media, as these women have used them, one gathers a sense of their strengths. Women's strengths are founded in non-violence to person or place: neither aggressive nor militant, but nurturing and persevering.

The selection was not easy. But with the help of numerous referrals and recommendations from arts organizations and guilds, regional and state arts councils, individual arts supporters, museums and retailers, these women have been chosen to share their ideas and personal philosophies, reflected in their work and through the integration of their personal and professional lives. Particular thanks are due Nancy Lindburg and Peter Sears at the Oregon Arts Commission, the writers and photographers who found the essence within the woman and her art, and the InUNISON staff people who worked so many extra hours to pull it all together.

*Ellen Nichols*

*Featured Artists*

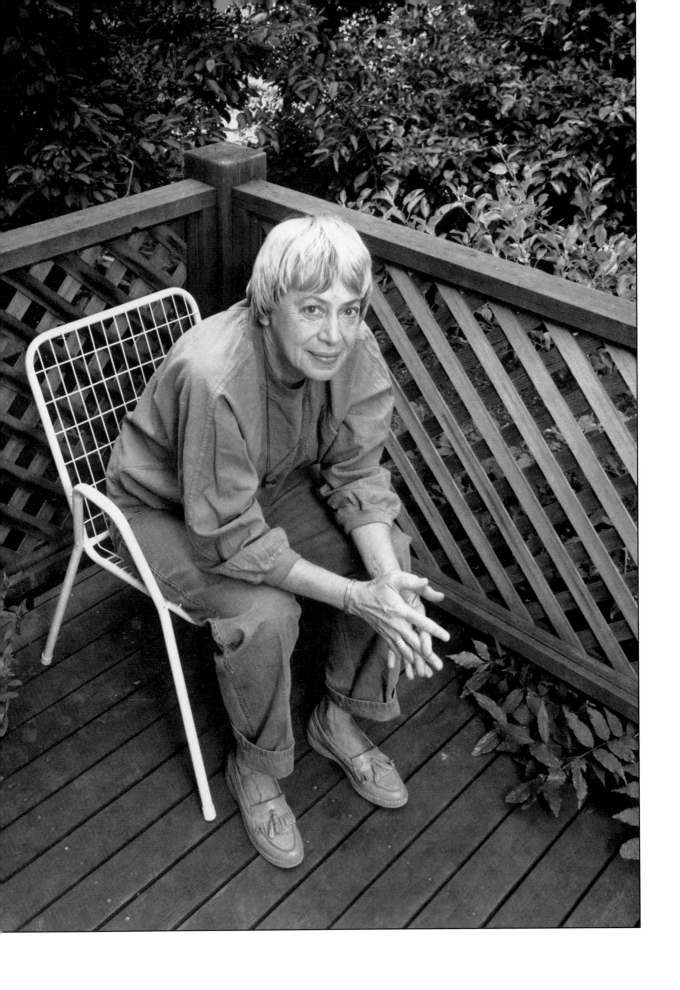

# URSULA
## K. Le Guin

*fantasy/science fiction*

Humankind and nature together are the substance of reality, to which human laws and desires must attune themselves. It's a Taoist world view to which Ursula Le Guin is attuned. Since everything one does may be important, she believes, our judgment of what is important may be quite mistaken.

"Like many women, I don't really live in incidents and events and adventures, but in a continuum where it isn't important that anything be more important. The way I live my life has shaped the way I live my life..."

Translations of art — and literature is particularly subject to analytic translations — tend to frustrate Le Guin. While a clearer understanding is certainly to the reader's benefit, she admits, when translation becomes a defined

*"A work of art is above all an **act** — not an **is** but a **does**. It's what it does that's important — what the reader and the words, acting together, do or become. Art **changes** us."*

meaning of the work, the art is undone, the creative nature muddied.

"A work of art is above all an *act* — not an *is* but a *does*. It's what it does that's important — what the reader and the words, acting together, do or become. Art *changes* us."

As a student and young writer, Le Guin was taught what literature should be by male definition. She learned how to write like a man, how to write *as* a man, she explains. Masculinism was the standard used to measure the value of a work — good insofar as it approached the condition of men's writings.

"Then the women's movement was reborn," she explains, "and gradually — very gradually — I am a slow learner — I learned how to write

like a woman. And *as* a woman. In other words, to value my own womanhood as a source for my art; to value exactly some of the things men (busy establishing their undoubtable manhood) devalue in art; to 're-vision' the world, as Adrienne Rich says, through a woman's eyes. I think if the women's movement, especially in literature, hadn't given me this strength and pleasure of writing as a woman, I would not have continued to grow as a writer."

A prolific writer, Le Guin has earned her reputation in poetry, science fiction, fantasy and other forms for both adults and children. She has published 43 books to date, her most recent, *Dancing at the Edge of the World*, a collection of essays, short travel pieces and speeches (even writers have to talk sometimes).

"I do my best thinking in fiction and don't try to translate it into any other terms."

Through fiction and fantasy Le Guin experiments with the possibilities of alternative worlds, envisioning, sometimes moralizing, always evolving, stretching, seeking out the possible in the improbable, pointing up the failings of so many of humankind's systems, creating options for a better world.

As for the source of her own creative spirit, she quotes Martha Graham: "The energy of the world is available to all of us. It moves the planets and makes everything work. We can all use it. Only we become frightened or frustrated or too tired to use it. I use it."

Photo: T. Hendrix/Text: E. Nichols

*Fragments of Dream*

# SUSAN
## Comerford

*"I'm an open person. I'm willing to expose my inner feelings. That is a hard thing for many people to do. But all those hidden thoughts and feelings are what count. What we do on the outside to conform doesn't count at all."*

Place is important to Susan Comerford. For the Glide printmaker has developed a means of living her art by focusing on the soul and spirit of place. The open spaces of southern Oregon and America's arid Southwest reflect the openness of people closely attuned to the land, as Comerford is.

Art may have come late to her life — the two-room school at Panther Creek had few resources to offer — but since first opening the oversized art books in the Las Vegas library, Comerford's education has been extensive. LaVern Krause and Fred Kline, both Oregon artists, have been important parts of the process.

Comerford returned to the family ranch in 1970 after 15 years in Nevada. There, beside the North Umpqua River, her children completed their childhoods. Her parents completed their lives. She was widowed in January 1989.

"I feel for the first time in my life that I've completed my responsibilities to my family. I've done it right and I am proud of that," she reflects. "My children are grown and married and developing in all the right directions ... my work is coming together and it's time to concentrate on that."

Comerford's prints have evolved into strong "spirit landscapes," earth-oriented and open, at-

tuned to the artistic reflections of her own inner feelings that she defines as a "universal place" — both male and female — the soul and spirit.

"I'm an open person. I'm willing to expose my inner feelings. That is a hard thing for many people to do. But all those hidden thoughts and feelings are what count. What we do on the outside to conform doesn't count at all.

"I feel a woman is a strong equal with a man; I don't try to put a woman's perspective in my works because  I am a woman and I know that it's going to be in there anyway. I come from this place — this femaleness — I expect a lot of myself.

"I hope that I am an example for my daughters. I'm in charge of my life, and through my art I'm doing something that is worthwhile, that adds to the flow of humanity; something that's sound and real, not a fad."

She has mastered several art forms, including painting, and has kept a series of journals through the years that have enhanced her creative processes and become an art form in themselves. But it is in printmaking Comerford has found a strong physical skill that particularly challenges her creative senses in its mix of elements. Her small, stylized hookline engraved in much of her work has evolved into a signature of sorts. And the often dreamlike prints incorporate the little elements of thought and earth with which we all build our lives.

Photo: T. Hendrix/Text: E. Nichols

# *RONNA* Neuenschwander

## *sculpting*

> *"It's hard to talk about my work in strictly visual terms, because it's about this whole other life."*

When Ronna Neuenschwander first went to Africa in 1983, it was to observe the camel caravans as the salt trains came in from the Sahara Desert. Research for an art project triggered her interest in the historic use of camels and elephants. Their exploitation was reflected in her sculpture.

When an invitation came to accompany a photographer to Timbuktu, she seized the opportunity to experience firsthand these majestic beasts performing their invaluable service. While there, she met a young man, Wague', a native of Mali, who later became her husband. They have made great strides in assimilating each other's culture. For Neuenschwander, as a ceramist, West African culture was very appealing, in part because of its dependence on clay as a primary material for all kinds of vessels and implements indispensable in everyday life. Her ability with clay helped secure her acceptance among the people.

The influence of West Africa is readily apparent in Neuenschwander's sculpture. "It's hard to talk about my work in strictly visual terms, because it's about this whole other life."

Nevertheless, in its appearance as much as in its content, we see the colors, the forms and the materials of the open, arid land. With adobe and earthenware, the artist shapes large, simplified figures filled with references to the architecture and work of the people. Added materials and objects carry further this connection. It's that "whole other life" that dominates one's perception of Neuenschwander's work. The figures evoke the grace and dignity of an ancient way of life that, to our Western point of view, seems impoverished. The artist shows us the rich culture to be found in the social relationships, the stories, the dreams and the courage of a people who must endure an unforgiving natural environment. Clay, the indigenous material, is an ideal medium for conveying this theme. "The pottery reflects history. Shards are everywhere. I pick them up and think about their past use."

Neuenschwander's affinity with clay germinated in a high school art class. She entered the fine arts program at the University of Kansas, specializing in ceramics. "I worked with the dance and theater departments, too, and that was very important because it made me more receptive to all kinds of artistic experience, especially in being sensitive to movement and sound." After graduation and a summer job at Oregon State University, she located in Portland. In 1979, she had a revelatory experience: she was a passenger on a plane that crashed at the Portland Airport. "I decided then to do with my life what I really wanted to do and not to be afraid to take risks," she said. That decision led first to acquiring a studio and then to accepting an appointment as artist-in-residence at Contemporary Crafts in 1980. In 1989 she collaborated with Wague' and filmmaker, Jim Blashfield, on *Devil-Snake*, which combines animation and live action. She created figures for it, including the snake of the title, and Wague' was the narrator, telling the African folk story on which it is based.

Photo: D. Browne/Text: L. Allan

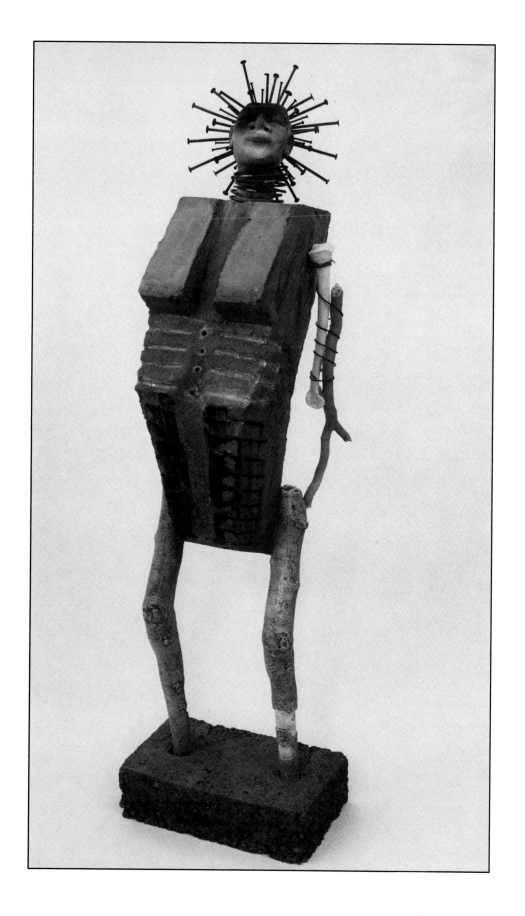

*Dreaming*

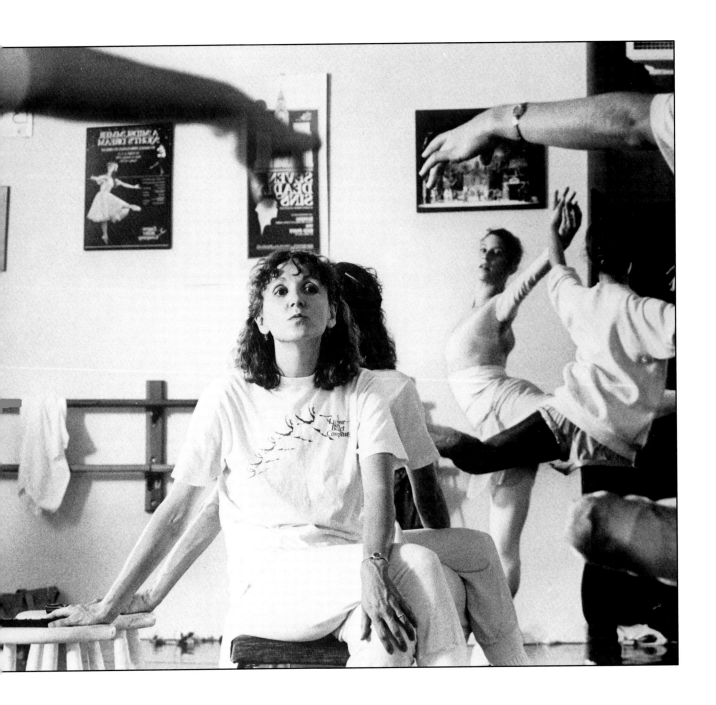

# *TONI* Pimble

## *dance/choreography*

Though Toni Pimble does not articulate a particular philosophy which guides her work, her artistic direction has helped propel the Eugene Ballet Company to national and international attention. Regarded as the premier woman choreographer in Oregon, Pimble has been invited by the Oregon Ballet Theatre to set several of its full-length ballets.

The hardest thing for Pimble as a choreographer is not creating an idea but staying on track with it as rehearsals progress. "That's why I like watching movies by good directors. You can see that no scene is wasted; it's well thought out and it all has to do with what each character has to tell about their story.

"In a piece for which the music is already created, I'm going along with certain guidelines that have already been set," explains Pimble. Established ballets, such as *The Nutcracker*, may require classical interpretation, while others such as *Silent Movie* and *Children of the Raven* are pieces she has conceptualized.

Asked about the role of inspiration in her work: "Inspiration? I don't know. It just pops into my head. I think when working on a project you absorb things and think about them. When you finally get into the studio and have to put something out, all this information you have been collecting falls in place."

Her ideas can take a number of different forms. "It might be just an expression of music that the audience can see as well as hear. With more dramatic pieces, I'm making a statement. For *Children of the Raven*, ultimately, the statement I was trying to make is for the Pacific Northwest Indians ... not to look at just the problems they face today, but at what their culture was before the white man came."

In rehearsals, Pimble's awareness shows itself on multiple levels. She looks at individual performances and their effect on the whole, as well as monitoring each dancer's emotional state that day. Her running internal dialogue may include a note that a female dancer is frowning because

> *"I think when working on a project you absorb things and think about them."*

her shoes are too tight or that a personal conflict is affecting the chemistry of a scene.

Though her concern is for the performance as a whole, Pimble has added empathy for female dancers. "I think Baryshnikov has done a disservice to female dancers in this country because his technical prowess is so explosive." In contrast, a female dancer may do point work that leaves other dancers gasping in awe but which is so subtly executed the audience is unaware of its difficulty.

Born and raised in England, Pimble left home at 14 to attend the Elmhurst Ballet School. An associate of the Royal Academy of Dancing, she danced professionally in England and Europe before coming to America 10 years ago with her husband and fellow dancer, Riley Grannan.

Grannan's first ballet teacher, Doreen Gilday, was selling the Eugene Ballet School and wanted a former student to take over. They bought the school and decided to form a ballet company as well. Grannan became the company's general manager and Pimble, artistic director, an arrangement they still continue.

The Eugene Ballet School now tours in nine Western states, has appeared in Taiwan and will be traveling to Victoria, B.C.

Photo: C. Coles/Text: M. Fisher

# MARLENE
## Moore Alexander

*watercolor painting*

The strong, simple shapes of the desert lend strength to both the artist and her paintings. A strong woman — one who likes life and space and the power of the desert — so Marlene Alexander describes herself.

Born in the Midwest, Alexander has been a resident of Bend since 1971.

"As a young girl I didn't have an art teacher to encourage me to work my own way and retain my creativity. I was fortunate to have a mother and grandmother who did lots of gardening and were observant of the world around them. They were always pointing out to me the color of the roses, the texture of the bark, the smells of damp Midwest basements."

Both mother and grandmother worked full time to support the family after Alexander's father died when she was six years old, she explains. There was little money for extras.

Now an artist, wife, mother and children's art teacher, "Here I am back to being a little person." She uses the image of a child that gathers treasures in a gunny sack, only to forget them. "Then all of a sudden, you just go back to that first bag (you had as a child) and start pulling things out."

For Alexander, the treasures she finds now are from the desert — rocks, bones, dried-up lakebeds. "I like to take nature and abstract it and simplify it. I find I'm always zeroing in and narrowing my focus to make a statement."

The barren landscapes of central Oregon radiate life through her use of light and color. Though her primary work is in watercolors and transparent watercolors, Alexander has recently begun work in acrylics because of the brilliance they offer. Whatever the medium, she seeks strong, simple shapes, working a series on a theme.

Alexander has two series of desert inspirations that she continues to add to, one of rocks, another of bones. Though drawn to the simplicity of the sun-bleached bones, she is often saddened by thoughts of how the creatures died. Some of her bone paintings are softened by the addition of flowers.

Alexander finds one of her challenges as an artist is to create "a beautiful negative space." A recent transparent watercolor she did is a case in point. While making breakfast she was struck by the beauty of broken eggshells on a plate. Because transparent watercolors have no white, she had to create the eggshells by defining the space around them (paper is used as the white).

"Think positive and paint negative," she urges her students.

"Nature again has provided me another subject that I'm going to study and that is pigs," she smiles, "which are large, simple shapes. "I've painted one award-winning pig painting and am now working on another study."

A juried member and past vice president of the Watercolor Society of Oregon, Alexander has won several awards and has earned the bronze, silver and gold merit awards in the Society. She is a founding member of Art in Public Places.

*"I find I'm always zeroing in and narrowing my focus to make a statement."*

Photo: M. Fisher/Text: M. Fisher

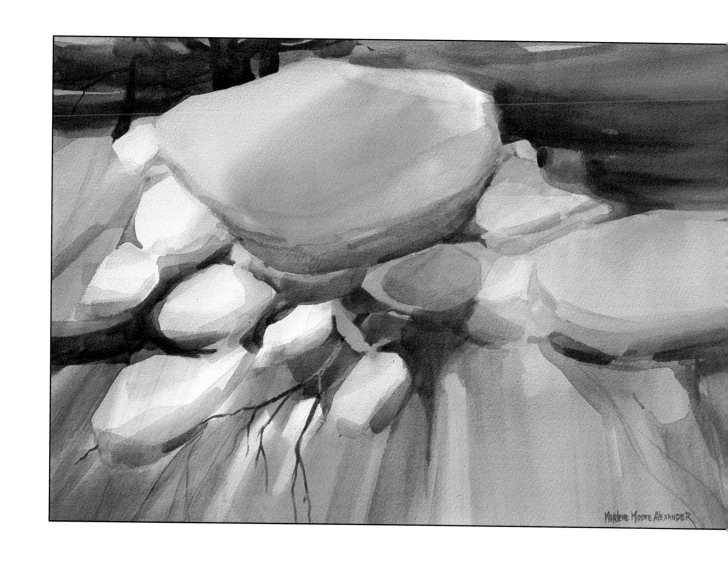

*Pumice Rock Hill*

# *EVA* Saito Noda

## *musical composition*

The works of composer/pianist Eva Saito Noda mirror her many worlds. She is a bridge between cultures, and listening to Noda's compositions is like taking a walk through her life: the quiet tone of a Japanese tea ceremony, the bustling beat of New York City, the windswept prairies of Alberta, Canada, or a soft, foot-padding walk in a Northwest forest.

These worlds have merged and Noda's life story is her musical story. "My music has taken me down alleys and streets I would never have dreamed of going."

Noda began drawing her musical worlds together while studying music education at Columbia University. There she learned Dalcroze — a very creative approach to teaching music through body movements.

"We, as people, are very musical. It is so much

> *"My music has taken me down alleys and streets I would never have dreamed of going."*

a part of us and rhythm is a part of our bodies. Music is becoming aware of these qualities to create a harmonious peace of mind."

A teacher encouraged her to further mesh her multiplicity of styles: "He said, 'Wake up, girl. Shame on you for not knowing your culture,' and sent me off to hear Japanese music."

It was a new experience for Noda, born in Edmonton, Alberta, where her parents had moved in 1912. "My dad had no interest in educating me in the Japanese culture. My parents felt we were part of the new world now. There were only six Japanese families in the area. I was very British and very French in my thinking at that time. I find I'm very grounded in the classical style. It is a strong influence."

Noda lived in Japan for four years in the late '50s. She taught music, led a traveling choir and helped with church organ and choir music.

Non-Japanese-speaking but Japanese-looking, Noda experienced culture shock. "They couldn't speak English and I couldn't speak Japanese. I felt frustrated. I walked like an American, talked like an American and behaved like an American. They just didn't know what to do with me. It extended my own awareness and appreciation of oriental life. I became more whole, because it (Japanese culture) became a part of me. When you listen to music from other cultures, you become a universal being. This is where the excitement is. It is part of what one has to offer. It's the variation and uniqueness of our personalities."

In 1968 Noda wrote a group of three pieces, *For the Children of War*, for flute and piano. New York flutist Jean Antrom performed them in a 1972 Carnegie Hall recital. "I got a big review. I practically fell dead, I was so stunned. That evening meant I really should try to compose more."

Noda studied with renowned Portland composer, Tomas Svoboda. After 18 years she is beginning to get commissioned works. Noda produces one or two pieces a year for a variety of instruments. Her compositions are short: "It's a part of my style of writing, not big and profound. I don't think I'll ever write a big symphony." Her latest composition, a set of six dances, was commissioned by Northwest guitarist John Temberelle, who performed the work at Lewis and Clark College in October 1988.

"My choice of this art form would have been extremely rough for me if I didn't know compromising," she acknowledges. When she was a young woman, World War II prevented Noda from going to London for advanced musical study. Instead, she opened a studio in Edmonton and taught piano. She chose a music education degree as another compromise, this time for survival. "I can't live on my composing," she says, smiling.

"We walk through these periods of our lives (compromises we must make), and we know they are not the main branch of our tree."

Photo: C.Borland/Text: J. Colombo

# DEBORAH
## DeWit

*photography*

*"Beauty is the essence of nature or human emotions."*

Gentle mists crawl over green, rolling hills. Arching trees frame a path of light, beckoning the viewer beyond what can be seen. Deborah DeWit's photographs ask questions and evoke mystery.

"I can drive down a road of farm fields and get gooseflesh," says DeWit, who describes herself as a farm girl at heart and a romantic.

"Light always attracts me first. A lot of times I'm taking pictures of light and the subject matter is incidental. Light is magical. It changes color, shape and composition."

A master of light and composition, DeWit will climb fences and wade through water to capture the fast-moving perfect light. DeWit is a self-taught photographer, a purist who doesn't use filters and refuses to crop or to manipulate photographs in the darkroom. She has sold thousands of photographs and is represented nationwide.

DeWit's artistic eye searches for the aesthetic, not the narrative: "I take a picture of something real, but I use that reality to portray something else."

"There are human things to communicate that are universal," she explains. "One of them is beauty. I don't mean prettiness, and I don't mean nice colors, and I don't mean decoration. Beauty is the essence of nature or human emotions. To get that across — whether it be in a photograph of a field or a window or some

human endeavor such as a building or place where people live and do their work — is very important to me. I've spent half my life looking at things and it's revealed to me an abundance of beauty. We often don't take the time to enjoy it or to even comprehend it."

For five years DeWit's search for beauty carried her on solitary trips throughout the world. She found beauty in wild and ancient Scotland, "where the weather is intrusive and the space, powerful"; in the desolation of an Australian desert, "where it hadn't rained for two years"; in an abandoned house in Malaysia, in Spain, in Mexico, in France.

"Photography is very limiting. You don't have the freedom to take a thought out of your mind and represent it. You have to go looking for that thought."

DeWit's parents, who emigrated to the United States in the 1950s, encouraged the search. Born in Indonesia, DeWit's mother is an artist in her own right. DeWit's father grew up in Holland and comes from a family of artists. In fact, DeWit's great-grandfather instructed Van Gogh at the School of The Hague.

"My mother gave me the view of life that you can be anything you want to be if you work hard enough for it. You can be a scientist, you can be an artist."

DeWit tried it all. She studied science at Cornell University.

She worked as a cook and as a gas station attendant. She drove tractors, hoed fields, drove cattle and traveled the world by herself.

"I've always believed that if I could do the job, I should do it," says DeWit. "If I can't do the job, then it's because I'm not good at it or I'm too small or not strong enough. A lot of men are too small and not strong enough to do certain jobs.

"I've always believed in myself as a woman. I don't try to be equal to men but only to be equal to myself."

Photo: D. Thornton/Text: J. Kempe-Ware

*Haunts of a Pre-Raphaelite*

Neither Students nor instructor have more than a few ounces of lycra stretched over their heaving body parts — anything more interferes with Julane Stites' inspection of her charges' form and movement; their attention to hers.

A young woman forgets and averts her eyes while pirouetting across the room. The teenager, already many repeated turns into an all-afternoon practice, is working for a better position with the city's prestigious Jefferson

> *"When a person has a gift, they have a responsibility to share it."*

Dance Company at Jefferson High School, Portland's magnet high school for the arts.

Stites yells, "Stop!" The pianist suspends the beat of Ravel's *Habanera* as the teacher, thrusting her arms upward, runs out on the hardwood floor and commands, "Dance with your face. Do you love it, do you love to dance? Then dance with your face — use your mouth, your nose, your eyes, everything! This is *dance*!"

"Dance" is what Stites defines as being "the artist's ability to interpret life and feelings as they pass through the body — whatever those messages the dancer feels are strong enough to convey."

Her lifelong drive to excel in that interpretation, whether ballet, jazz, tap or gymnastics, has taken Stites places others have not gone.

At 13, Stites had the lead in a Bolshoi Ballet production; at 17, she was a principal dancer with Marge and Gower Champion in Broadway's *Happy Time*, followed by her being cast for a principal dance role in *Promises, Promises*, a David Merrick production, also on Broadway. She's performed in television features on the *Tony Awards, The Ed Sullivan Show, 60 Minutes* and *Saturday Night Live*.

"Rhythmic patterns" have also put Stites, who

says, "I don't want to be labeled," prominently behind the scenes. For the Jefferson Dancers, whom Stites has taught since 1981, she choreographs three works a year. In 1984, Stites' choreography of *Yellow Jackets* won the International Fred Astaire competition in New York City, in the jazz trio category. Stites herself left Portland's Parkrose High School when she was 16, finishing at Professional Children's School in New York, between play performances.

For her choreography (with Alex Pepe) of Portland's Civic Theatre's 1987 production of *West Side Story*, she won a Willy award. She also choreographed the Civic's production of *Evita, Peter Pan* and *Jesus Christ Superstar*.

The "Stites style" of choreography has gotten the attention of the California Raisin Advisory Board, who hired Will Vinton to produce the television special, *Meet the Raisins*. In addition to determining the rhythmic movements of the California Raisins, Stites also did the dance foley (soundtrack) on the Michael Jackson raisin commercial released in September 1989. Stites choreographed for the live dancing raisins, who also in September kicked off a 10-city tour of the United States and Japan.

Still, the dance conversation that makes Stites passionate is when she describes her work as a teacher. "My mother has owned a dance school for 37 years, ever since I can remember (the Merleen Stites School of Dance in east Portland), and she believed in the importance of a classical ballet background." What Stites is careful about is criticism, which, she says, can "break a dancer's spirit. You never say, 'You'll never be a dancer because you don't have the right kind of body.' Dancing takes courage. If a child is taking a risk, you don't say, 'No, no, don't do that.'"

When the pace tempts Stites, the mother of five children — all at home — to consider giving up teaching, she reflects, "I feel a responsibility to be involved in the dance world, to share what I know. When a person has a gift, they have a responsibility to share it."

Photo: C. Borland/Text: S.M. Wood

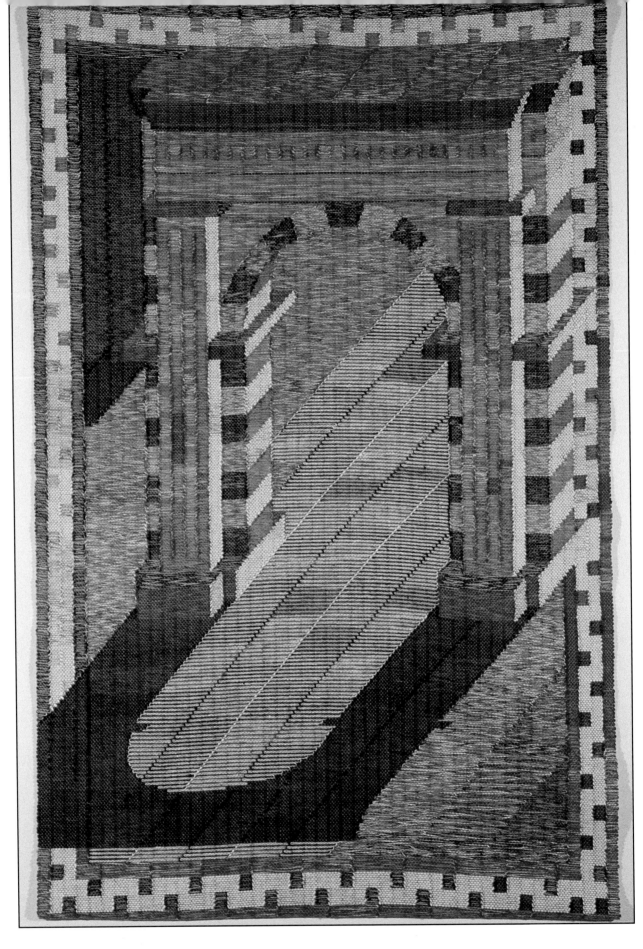

*Red Arch*

# JUDITH
## Poxson Fawkes

### *weaving*

*"...this work can be isolating and other-worldly, and it can also be long, lonely and laborious."*

When one thinks of a landscape, traditional elements may come to mind: flowers, trees — a waterfall, perhaps — rendered in watercolor or oil. Judy Fawkes's idea of a landscape, however, is much less traditional and far more complex.

Plotting her designs with infinite care and preciseness, Fawkes takes the traditional art of weaving and brings to it elements of classicism blended with modern technology. Her "invented landscapes" recreate the classical symmetry of Greek architecture in designs generated on a computer.

These designs, called axonometric designs, use only horizontals, verticals and diagonals, and give the weaving a classic, yet very modern look and feel. A current work in progress, for Portland State University, was graphed on a computer and, when finished, will represent a high-tech aerial view of the campus, executed in natural linen fibers.

For a time Fawkes worked with aerial landscapes, first taking photographs of cities from the air and then creating weavings from a mile-high perspective. Her first aerial landscape weaving was commissioned for Portland's Louisiana-Pacific Building. Commissions from other cities soon followed, but she eventually tired of hanging out of helicopters and small planes with her camera.

"I wanted to create my own landscapes instead, and I became very interested in using classical architectural models, such as columns and arches, and working in strict proportion.

"I like preciseness, exactness, order; even in gardens I prefer geometric green ones to gardens full of flowers.

"The loom by nature is extremely structured, with the vertical warp and the horizontal weft dictating what you can and can't do. If you ignore this, you ignore the nature of what occurs there. But I don't find that limiting: it's liberating. You ask yourself, 'Well, what *can* I do?' and work from there. With a blank piece of paper there are a thousand possibilities and a thousand things that can go wrong. But with such a systematized work as weaving, the possibilities seem infinite.

"Weaving is definitely female-dominated. Although I don't think it has to be gender-specific, some cultures have always termed it women's work. Scotland is one of the few places where men have been very involved in weaving, because they wove the tartans. But in certain cultures weaving has always been more of a craft than an art, and women have been the ones who have been the weavers."

Fawkes lives near Forest Park in northeast Portland, a neighborhood of large older homes where many neighbors are also artists and writers. "I like to work at home, knowing there are other artists and writers working nearby. Sometimes this work can be isolating and other-worldly, and it can also be long, lonely and laborious. So it's nice to know someone else is out there."

Her husband, artist Tom Fawkes, has a workroom upstairs. What must it be like to share home and work space with someone who, in essence, is a competitor? Living with another artist, Fawkes says, offers distinct advantages.

"We have always had quite an equal relationship, especially in terms of our work, because another artist really understands the need to finish a project, to get ready for a show. He understands that sometimes, you've just got to get the work out."

Photo: D. Browne/Text: M. Lowry

25

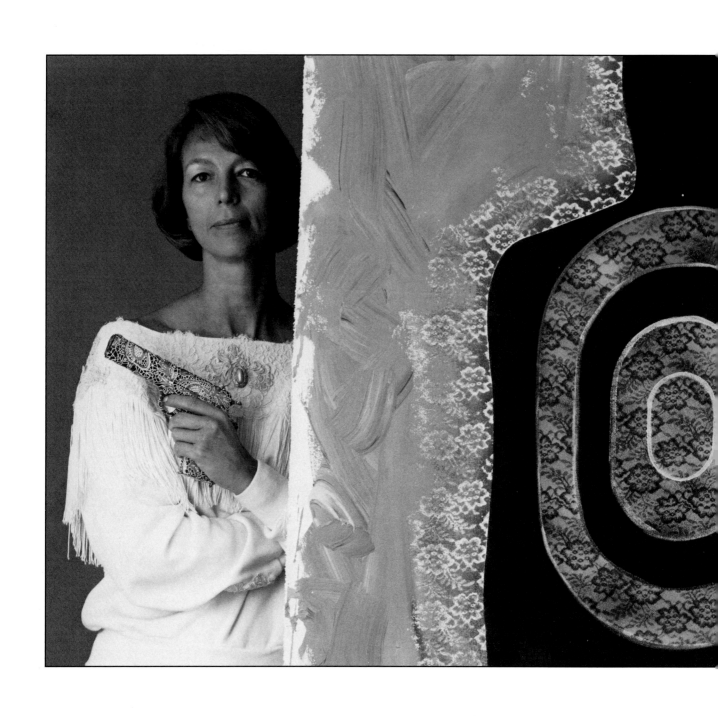

*Mrs. Johnson's Gun — Lace Target 1986*

# PHYLLIS Yes

## mixed media painting

"It struck me, when I was watching Oliver North on TV, that all the ribbons and medals he was wearing on his uniform are prizes and recognition of a kind that women — and what they do — don't get. Women, too, are noteworthy, courageous and charitable, but there are no outward symbols that are awarded to them."

That observation was the inspiration for a series of sculptural wall pieces called *Honored Women*, through which Phyllis Yes pays tribute to the dignity and heroism of women. Now numbering almost 20, these painted and decorated clay heads and torsos encompass the decorative styles of various races and cultures in their adornment. Jeweled epaulets and pat-

*"...by hanging onto these rigid outward symbols of masculinity and femininity, we exaggerate the differences between us."*

terned scarification have cultural references along with those to gender. The torsos are armless, and their rough edges and dull paint give the impression that they are artifacts recently unearthed, a reminder of the ancient origins of cultural traditions.

Yes's interest in the cultural significance of gender roles began when she was a member of the Peace Corps in Brazil in 1968-69 and observed habits of behavior and styles of dress and adornment associated with gender identification that, although dramatically different from those she had grown up with in Minnesota, were just as specific, ingrained and rigid. On her return to the United States, her art began to reflect that interest and continues to take as its main theme the questioning of sex roles. How do we define masculinity and femininity? She poses the question by confusing the issue, covering a Porsche sports car and weapons with lace.

"I'm an artist. I start with an idea; the materials and process follow. I use whatever is necessary to bring the idea into being." Her ideas have taken form not only in found objects, such as the car and weapons, but also in furniture which she designed and built, clothing and video.

A current project is once more in the traditional medium of paint and canvas. "I have to trust my instincts, even when I don't understand where they're leading me."

Although she considers herself first and foremost an artist, she is also a teacher and scholar. With a Ph.D. in art education, she teaches painting, drawing and design at Lewis and Clark College. Her scholarly pursuits took her in 1988 to New Guinea, where, as the recipient of a National Endowment for the Arts fellowship and with additional support from the Oregon Arts Commission, she traveled to several villages to observe body adornment with emphasis on its relationship to gender specificity. "There, the males use lots of color, mimicking birds, and the females tend to be drab. Men, not women, wear color on their faces, flowers in their hair and necklaces." Because she was a foreign woman, men shared with her their interests and traditionally male activities. At the same time, she was readily accepted by women, thereby broadening her insight into cultural traditions.

The New Guinea experience resulted in two important changes of direction. She made a video documenting the trip, found she liked the medium and is continuing to explore its possibilities. She also began a series called *Totems*, in which molded, mask-like, genderless faces project from a painted background. By minimizing color, eliminating hair or other identifying details, she suggests the underlying humanity and dignity of both sexes. Her studies have led her to believe that "by hanging onto these rigid outward symbols of masculinity and femininity, we exaggerate the differences between us."

Photo: R. Buonanno/Text: L. Allan

# DORIS HELEN
## Nelson

*enamel jewelry*

*"All my life I've needed to make things that I could hold and that were a product of me."*

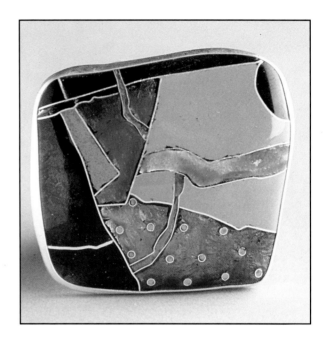

Like the shattered glass inside a kaleidoscope that collides to form a whole, enamelist Dorie Nelson's vision is composed of fragments of color and form. However, it is the pieces, rather than their totality, through which she expresses her art. Her way of seeing is rooted in a lifelong fascination with looking at things through a lens.

An early gift of a microscope taught her to appreciate the often unseen dimensions of nature. She then began using binoculars and telescopes, becoming fascinated with the empty or "negative" space surrounding objects, giving them definition.

"If you made yourself a window (with your hands) and moved it around and looked at things through it, you'd see what I was looking at."

Nelson uses her "window" to make drawings of the relationship between objects and their negative space. The drawings are kept in a notebook, which she reviews when she's ready to make an enamel piece.

She begins with a copper or pure silver base; each is then set in precious metals. Enamels are a special kind of glass fused to metal. Oxides color the metal permanently and may be opaque, transparent or translucent. Nelson fires each piece at very high temperatures until the glass melts. While one firing may take only one or two minutes, each piece is fired as many as 40 times.

Nelson increasingly removes details from her designs, seeking simpler pieces, creating varying illusions for her audiences with different surfaces or depths of opaqueness.

The intricacy of her work precludes mass production. She does about three pieces a month, spending in excess of 40 hours on each. A position as acting director of Linn-Benton Community College's outreach center allows her to continue as an artist.

"All my life I've needed to make things that I

could hold and that were a product of me. I've enjoyed it; it feeds my soul. Nothing has ever gotten in my way. I'm not very sympathetic with someone who says, 'I don't have time to be creative.' I do what I need to do to nurture that: for me, it's solitude and lots of personal space."

A fourth-generation Oregonian, Nelson was born into a family of strong women, a fact she feels has "freed me from worrying about whether my work is male or female. I think what's important is that people who are artists or are creative find stimulation somehow."

Two strong influences have been mentor, Martha Banyas, a Portland visual artist, and *art nouveau* jewelry and glassmaker, Rene' Lalique. When Nelson read on a Thursday that a show of his enameled jewelry was due to close in San Francisco, she drove there and back that weekend.

The source of creativity, she says, "is being sensitive to everything around you."

Photo: C. Cheney/Text: M. Fisher

29

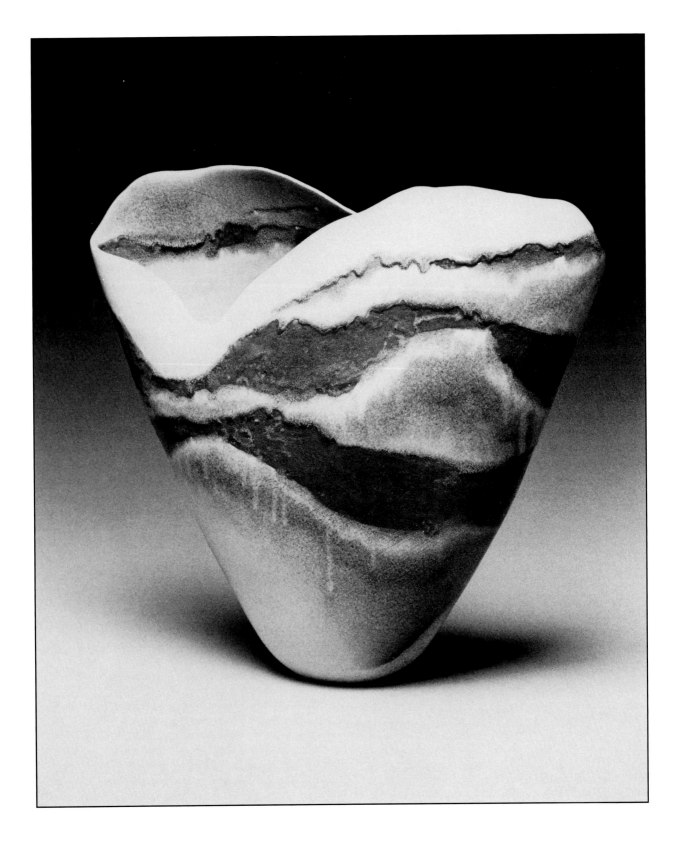

*Coiled Vessel*

# RURI
## Sato

*"I love to make pieces people can live with for a long time in their daily life..."*

Ruri creates porcelain pottery reflecting the hills, forests, mists and changing sky of her rural setting near Sheridan. She lives close to nature, with each day of each season influencing her mood and work, which in turn show her intimate concerns: the rocks, the very bone structure of the rolling mountains, the contrasting shapes of clouds as they drift over the lights or darks of the browns and greens surrounding her hillside studio.

Hand-building and altering the forms thrown on the potter's wheel are techniques she treats in a highly individual series of forms and shapes.

"The ridges of hills in contrast to the shapes and tones of clouds give me many thoughts toward the form and texture I am working with at that moment. I have been working with vessels which have space inside and openings, and I have just been enjoying working with these forms.

"I love the raw stage of the porcelain before the firing, with its sensuous softness and whiteness. And so my works are very subtle and quiet."

After growing up in Japan and graduating from college in Tokyo, marrying an American and coming to the United States at age 26, Ruri received a master's degree in library science in 1978.

Her career as a potter began at the Creative Arts Workshop in New Haven, Connecticut, in 1974. New England potters were a strong influence, especially Toshiko Takaezu, now at Princeton.

Ruri returned to Japan briefly, then moved to her studio in the Sheridan hills in 1980.

From her early apprenticeship with the great Japanese potter Shimaoka, near the Japanese Living Treasure potter, Hamada, through her many hours working with clay and fire, Ruri now concludes, with a smile: "I would love to have a wood-burning kiln in Oregon."

Ruri has taught pottery, Raku and the use of salt kilns at Western Oregon State College, lec-tured on Japanese pottery and conducted workshops at the Oregon School of Arts and Crafts and the Southern Clay Folk in Ashland. "One has to make a living," she says with a smile.

Ruri has participated in many international exhibitions and in 1988 was included in one of Japan's major competitions, the Japan Contemporary Crafts-Arts Exhibition at the Tokyo Metropolitan Fine Arts Museum, as well as the "American Crafts Traditions" in the San Francisco International Airport. Her works are in many public and private collections.

Ruri is presently serving as visiting artist at Kapiolani Community College near Diamond Head.

"I am most impressed with the Hawaiian mountains, the sharp edges of these very new (compared to old Japan) mountains rising from the changing colors and tides of the ocean."

Ruri believes that the use of her works will be up to "the user's own creativity.

"I love to make pieces people can live with for a long time in their daily life, just by watching, touching and using them when they want and in their own creative way."

Photo: D. Thornton/Text: D. Thornton

31

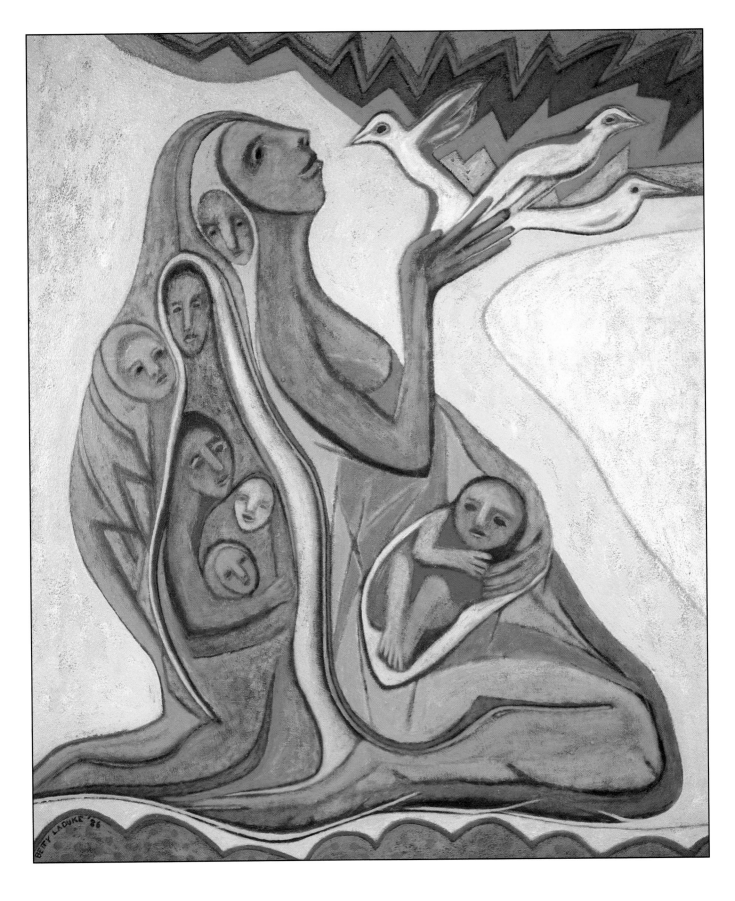

*Latin America: Tomorrow (Homage to Edna Manley)*

The aloneness of a woman artist is in her face. Yet, Betty LaDuke's strength of purpose and faith in herself as an interpreter of the human scene are evidenced in her prolific artistic production. She trusts friends, poets and sensitive people, rather than the commercial scene, to tell her if her work is good or bad.

"I want my work to be a celebration of life," she says. And it is.

Her home and studio are lit with color and alive with the forms and figures of her paintings. Her multicultural, mythical interpretations are sinuous, sensuous, dreamlike, joyous and unconventional. She blends the surreal and the political while depicting "the critical life and death issues of women, as well as men, explaining and sharing it nationally and internationally."

> *"I continually struggle to master the juggling act, but bonding with my family and friends on a multicultural, global level nurtures me."*

For LaDuke, an early symbol of personal despair was the bird. Birds now populate many of her paintings, becoming for her the keepers of dreams soaring. Another pervasive theme is the duality of woman, as young bearer of new life, and as old, wise healer. Birthing scenes, with woman as a strong, universal figure, have been reinterpreted in acrylic from the life-sized, carved figures she discovered in Papua, New Guinea. Of her work one art critic said, "Hers is a universe in which a multitude of mythic visions come alive in the creative, female matrix."

Artist, printmaker, writer, lecturer and feminist commentator, LaDuke has been firmly rooted in Ashland, a member of the art faculty at Southern Oregon State College, since 1964. But her need to reach beyond that relatively secure but narrow world has taken her on journeys to India, Asia, China, Latin America, New Guinea, Borneo and Africa. Her travels instill in her an international vocabulary of motifs to draw upon when she returns to her studio.

From her trip to Africa in the summer of 1989, she returned, as she has done for the past 20 years, with many sketchbooks filled, to begin again a year of creative work.

Her travels have resulted in not only new, vivid visual images, but in books exploring the lives and artistic expression of women involved in the process of social change. *Companeras:*

# BETTY
## LaDuke

*acrylic painting*

*Women, Art, and Social Change in Latin America* was published in 1985 by City Lights Publishers, San Francisco, and is in its second printing. Her second book, *Africa Through the Eyes of Women Artists*, is a 1990 publication by Africa World Press, Trenton, N.J.

"My time is divided and fragmented, but what can I give up — teaching, traveling, writing or studio work?" she asks. "I continually struggle to master the juggling act, but bonding with my family and friends on a multicultural, global level nurtures me. Therefore, I have the need to continue sharing, visually and verbally, examples of human dignity and hope."

Photo: H. Motley/Text: J.F. Anderson

33

# KATHERINE Dunn

## *fiction*

*"Sports are art forms, real life dramas, actors and actresses going through performances of reality..."*

Finding the exact word to describe Katherine Dunn's third and latest novel is easy. Nearly everyone who picks up a copy of *Geek Love* (Alfred A Knopf, 1989), whether or not they finish reading it, calls it controversial. Contained in a fluorescent orange jacket, it is a dark story about a carnival couple who deliberately design their children to be sideshow freaks. Dunn, the woman, however, is anything but polemic — according to those who know and work with her.

"Yeah, she's eccentric. Quirky, and independent, too," says *Willamette Week* editor, Mark Zusman, Dunn's boss (if she has one at all) since she began writing "The Slice" column in November 1984. Zusman opines: "Katherine's strength and appeal is the clarity of her writing, its humor and vividness. Katherine strikes the chord in all of us that says, 'Right on!'"

Thousands of readers agree. *Geek Love* has been nominated for a Hugo Award, is presently published in 10 languages, is in its fourth printing and has been selected as a Book of the Month and a Quality Paperback Book Club alternate. *Geek Love* has earned Dunn a contract to write a second novel for Knopf (the manuscript due September 1990) — this time her signature has garnered a $175,000 advance.

Not bad for a just post-World War II baby who has paid the rent by working as (among other things) a house painter, bookstore clerk, bartender, proofreader and teacher. She describes her background as "standard American blue-collar of the itchy-footed variety. We're New World mongrels ... My mother is an escaped farm girl from North Dakota, a self-taught artist and painter. My dad was a third-generation printer and linotype operator and by all accounts, a fabulous ballroom dancer. He was jettisoned from the family before I was two. I have never met him and have no memory of him."

An avid fight fan, Dunn is currently a boxing correspondent for the Associated Press (when Marvelous Marvin Hagler out-boxed Thomas Hearns in Vegas at Caesar's Palace in 1985, 2,000 journalists attended. Dunn, however, was the only woman writer to cover the event). She says, "I am interested in boxing because it is a totally human thing. Sports are art forms, real life dramas, actors and actresses going through performances of reality — 50 percent of it is theater."

Dunn, who describes herself as "pathologically curious," says, "The word 'art' has a lot of baggage attached to it. It is too often used to mean something you need a Ph.D. to understand; something you can appreciate only in whispers. For me, art is a set of functions — or one set of functions for the author and another function for the audience. When it is good, these functions coincide. Even a velvet toreador painting or a plastic flamingo, if it causes a leap of the heart, is art for the person it touches and pleases."

Dunn rolls her own tobacco, this time while talking about writing as a female. "My effort is to get beyond gender; to make my seeing and writing as unlimited as possible, as broadly human as possible. I will not hide under a pudendum of politics. The work has to stand alone."

In her apprenticeship as a writer, according to Dunn, "Most important was my discovery of the *subject*: that all my skills and talents were only tools in the service of the subject, that my success had to be measured in terms of how good a conduit I was for carrying the subject into the mind of the reader, that on their own my golden words didn't amount to a fart in the wind..."

Katherine Dunn. Telling it, very colorfully and a little controversially, as it is.

Photo: C. Borland/Text: S.M. Wood

*Journal Entry: Red Discovering Itself*

# MYRNA Burks

## *printmaking*

> *"There's an energy that comes with working together, figuring out solutions to problems, generating new ideas..."*

In the large, airy printmaking workshop that is North Light Editions, Myrna Burks, one of its two owners, describes the effect that collaborating with other artists has on her own paintings and prints. "There's an energy that comes with working together, figuring out solutions to problems, generating new ideas; it keeps you consistently on course."

Burks pushes the boundaries of printmaking materials and techniques in order to produce prints to match — or even to exceed — the collaborating artists' visions. In so doing, she finds the impetus for her own work, as, for example, in the collages that came as a result of seeing the colorful scraps left over from trimming prints.

An abstract artist, Burks says, "My art is about formal elements and how to orchestrate them."

Working with a combination of monotype processes, collage and drawing, she creates abstractions of delicate beauty, in which the materials, processes and ideas are synthesized. Cut paper shapes are adhered to the background paper under the great pressure of the printing press so that they are almost indistinguishable from it. After going through the press, when color applied to the plate is picked up in addition to the paper shapes, the piece becomes a ground for drawing — or more specifically, mark making — as the lines act to energize the surface rather than to describe a particular form.

"Recently, I heard a lecturer refer to collage as the true art form of the 20th century because it brings together disparate things and gives them a new context and identity," Burks said in discussing her current work. The observation reflects the complexity that has come about in collage as well as in modern life. For Burks, it represents a coalescence of ideas and emotions as well as of materials and processes which, as in life, becomes the artist's unique creation.

After earning a master of fine arts degree, Burks spent four years as a printer fellow and curator at the Tamarind Institute in Albuquerque, New Mexico, one of the foremost print centers in the country. As a master printer with many options, she chose Portland for its livability. In 1981, she and her partner, Vicki Vanderslice, founded North Light Editions, which now attracts many well-known artists whose prints from North Light are in major collections all over the world.

While the collaborative aspects of printmaking are an influence on Burks' art, equally important is the introspective practice of journal writing. Fragments of thought, like fragments of paper, often reveal unexpected beauty and might even be thought of as a collage built of words. The titles she chooses, often from the journals, combine with pictorial elements to convey a visual, poetic experience. "Both the outer and inner sources of my work enable me to be open to process and experimentation," she said.

"Making art is like making my life; as my life evolves, so does my art."

Photo: D. Thornton/Text: L. Allan

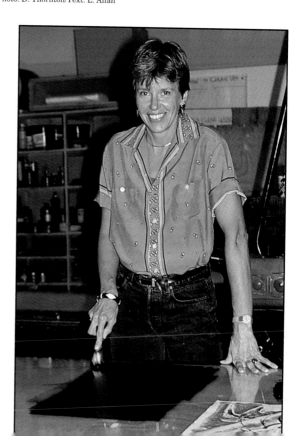

I went to the wall one day,
went to the machine,
punched my card in and waited
for money to come out.
Waited. Watched the screen.

Do you need more time?
the screen asked,
the machine screen asked.
No! I answered,
I want money
in multiples of twenty.
I want Ready Cash.

But the machine gave no Ready Cash,
asked me only:
Do you need more time?
Over and over I punched it,
swore, paced, tapped buttons,
glared at the person
staring over my shoulder.
All the machine would say was:
Do you need more time?

Disgusted, I took my card
and left it, the machine.
On reflection
I realize I missed my chance.
What have I done?
I could have said: Yes. Yes!
A hundred years,
a thousand years,
in multiples of twenty.

It does no good,
though I go back daily
to the same place, the same machine,
slide my card in like a lover's tongue,
wait for it to ask me.

It never asks.
All it gives
in multiples of twenty
is money. Money.
Money.

(Published by *Northwest Magazine* in 1985 and reprinted in *What We Say to Strangers* in 1986)

# BARBARA Drake

*poetry*

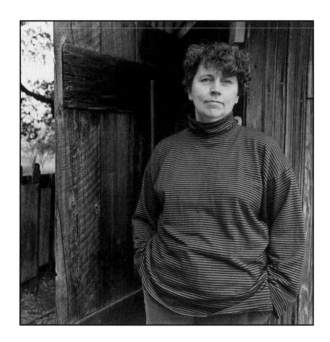

*"Art is the world I make up. It is inventing things — not out of nothing but out of something."*

It was gray the day Barbara Drake drove away from snow-blown Michigan. The storm worsened as she left her marriage and headed toward the Pacific Northwest and resettlement.

She drove south until dissolving ice allowed a further western direction. Again, another blizzard. Once more, she turned south until another relenting front let her go west. Then a flood covered the highway. She found herself again on a southern plane in order to get west. And so it went...

"That was 1982. I ended up in Las Cruces before I could finally get on a highway that let me get to Portland."

Drake, whose Kansas family first brought her to the Northwest when she was two, graduated from Marshfield High School in Coos Bay. She then earned a bachelor's degree in English and a master of fine arts degree in creative writing from the University of Oregon.

This story of perseverance is typical of Drake, who applied consistently for 15 years to the National Endowment for the Arts until, in 1986, she received a $20,000 grant, allowing her to pursue her style of writing.

It is a style predicated on familiarity with frustration. With her barely used M.F.A. in

hand, the young Drake was once told by a Midwest faculty head that since Drake's then-husband was already on the staff, her application could not be considered because "if I hire one faculty wife, I'll have to hire them all."

Many years later, just before her 50th birthday, Drake earned tenure as an associate professor of English at Linfield College in McMinnville.

While she has published fiction, it is Drake's poetry that has earned her her reputation as an original, once again, due to perseverance: "Through the '70s, while teaching poetry, I worked on classroom exercises. Then, through all of 1980, I worked on a book proposal incorporating those exercises." The book contract for *Writing Poetry* (Harcourt Brace Jovanovich, 1983) was signed in 1981.

Drake's poems have also been bound by Breitenbush Press — *What We Say To Strangers* (1986), by Red Cedar Press — *Love at the Egyptian Theater* (1978), and in various chapbooks.

Asked to define art, she said, "Art is the world I make up. It is inventing things — not out of nothing, but out of something."

It is Drake's interpretation that causes the reader to ponder that "something" long after the lights are out.

Barbara Drake lives on a farm in Yamhill with her husband, where they keep company with a couple of geese, a flock of sheep, some bees and two border collies.

Photo: C. Cheney/Text: S. Wood

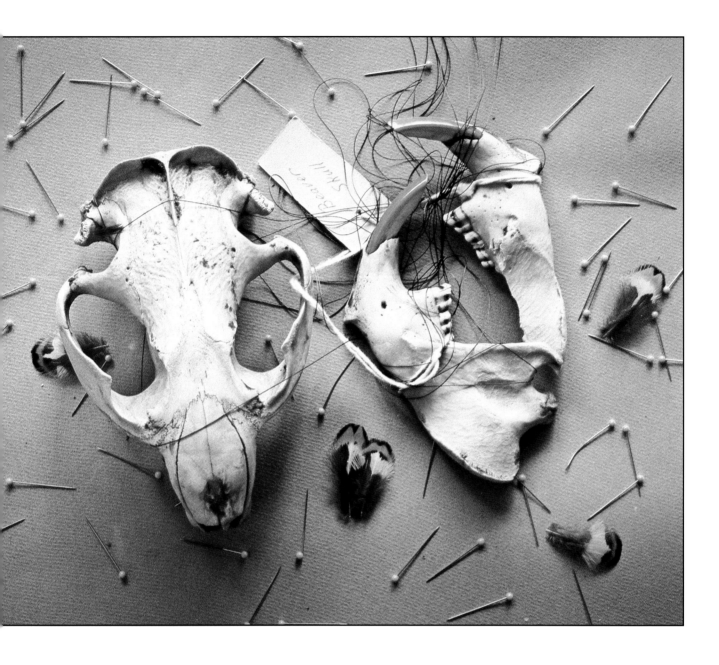

*Beaver Skull*

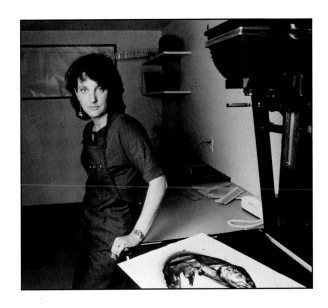

# DIANNE
## Kornberg
*photography*

Dianne Kornberg is a creator of a parallel universe in which the dead come to life, the lost are found, the grotesque are made beautiful.

A photographer working in the milieu of found objects, Kornberg creates her universe from plastic, bones, grass and refuse — things natural and man-made, dropped, discarded, lost and strayed. Water-swollen books, crab carcasses, bird skeletons and beach findings are all transformed by the lens of her camera.

Although she began as a painter, for the last nine years she has concentrated on photography. "The camera transforms images, and it renders detail in a much different way (from painting). In my early works with found objects, I was very interested in building environments, in playing a kind of visual game of 'what is the scale?' in which you weren't quite sure how large the object might be."

Later her work began to focus on the life forms for which she is perhaps best known. Some people have been taken aback by the use of animal skeletons and biological specimens in her work and have labeled it as macabre. But Kornberg finds a vitality in the underpinnings and leftovers of life.

"I have always been interested in biology. Bones, skeletons, dead animals are all in the process of transformation; they're being acted on, they are in transition, they are becoming something else. These images carry the vestige of life and I find them much more mysterious than simply dead. I see an ongoing process in them, and I think they have a powerful statement to make about our environment.

"I'm looking for things that are not so pretty and concentrating more on overlooked images in the environment, things with abstract formal qualities."

The images Kornberg chooses can be disturbing, both in their visual impact as well as their social comment. *Nest of Pins* juxtaposes the soft, feathery texture and image of a bird's body upon a sharp, man-made field of steel pins. Other works show animal skeletons bound with thread or string, held in place by an armature of pins.

Some of her works, however, display a subtle humor: a galaxy of crabs dance in black void; tiny golden anchovies swirl in a vortex. The carefully constructed arrangement of these shapes lends a whimsical anthropomorphism to the non-living yet lively subjects.

Kornberg's focus is constantly evolving. She is now beginning to work with more verbal themes, in contrast to her previous concentration on the purely visual. The concept of women finding a credible voice for expression is important to her.

"Feminism is having more to do with my work these days. It's very personal work: I'm not sure that my art is really political because it's more concerned with emotions and personal expression — but the impact of being a woman in this culture has a definite effect on my work."

Photo: D. Browne/Text: M. Lowry

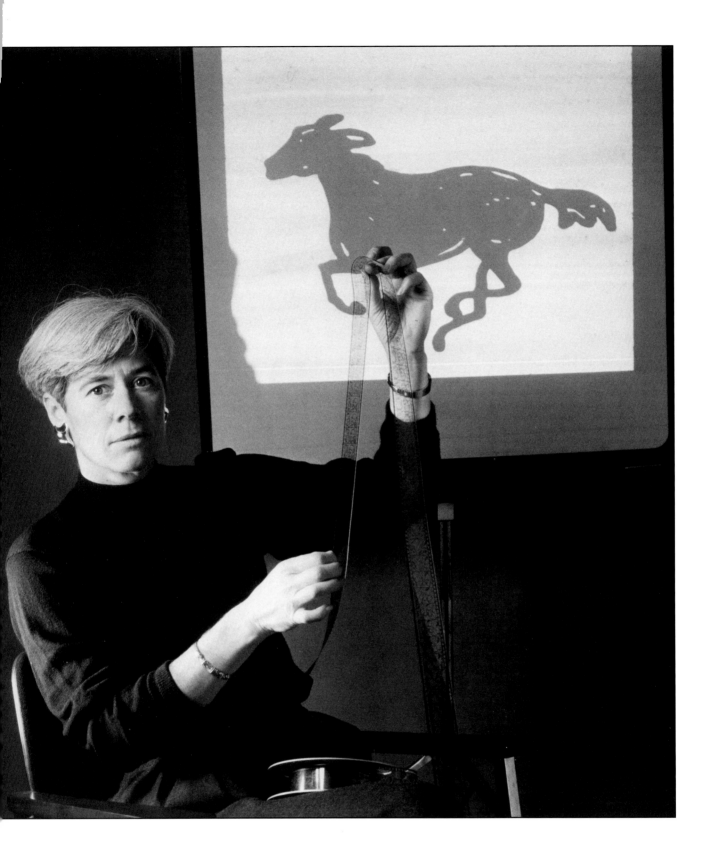

# ROSE Bond

## film animation

Rose Bond went through an entire college-level art history class in the '60s without ever encountering mention of a woman artist. The only female faculty member taught art education.

"I kept sensing I was regarded as a "Sunday painter"; there was no expectation for me to become a professional artist.

"That visual presence of ourselves as full beings is so often missing. Where are the heroines? Where are the inspirations for girls? We don't have enough heroines."

Bond did not yet have the insight to ask those questions during her college years. But she did notice the details of women's lives played out across the bowls of antiquity; it sparked an interest in archeology and ancient fables. When, a few years later, she began researching women's history, she encountered a series of Celtic myths about women. The stories lent themselves to animation through characters who changed forms and told their tales in an ancient, oral, storyteller manner.

Bond's drawings could change form, too, through film. She began exploring animated film to bring the Irish stories alive. Ironically, she never liked Saturday morning cartoons as a child, she recalls, "because of the violence. As I've grown older, I also realize I don't like their sexism. The challenge here is to work with a medium that hasn't done women too many favors and with it produce a positive expression of what it means to be a woman."

As an independent film maker, Bond is in full charge of her production. But it is a time-consuming, precise art form. Instead of drawing large images to be shot down onto film, Bond draws and colors each frame directly onto a clear celluloid strip, under a magnifying glass. The result is a rapidly-moving film, pulsating with an energy that enhances the fable. Voice and music are combined with the finished drawings at a facility in Seattle.

Bond spent two years researching, writing, editing and drawing *Cerrid Wen's Gift*, the first of her Celtic film trilogy, checking the accuracy of her work with Irish scholar Mary Condren. Composer Micheal O'Domhnaill composed the original score for the nine-minute piece.

There has also been an Oriental influence on Bond's work. She finds in Eastern art a perfected beauty in line. "One is so aware of taking a static thing — a mere line — and making it move. Through animation I can breathe life into those lines."

Despite its lack of an accredited film school, Portland has become known as a town supportive of animators. Part of it is no doubt the support animators give one another.

But the animator's art is a difficult one commercially. The artistic skill is more readily recognized in Europe than in America, Bond feels. And art collectors "want something to hang on their walls." But with the increasing access to video, more people are acquiring short art animations. Bond's work has been presented at art film cinemas and international festivals and has even found its way to *Showtime* cable television.

"I want my art to become part of a dialogue. There is an excitement that comes in women redefining themselves. Whether you approach it from an entertainment level or intellectual level or political level, I would like my films to contribute to those ideas. It seems worthwhile to me."

*"There is an excitement that comes in women redefining themselves."*

Photo: D. Browne/Text: E. Nichols

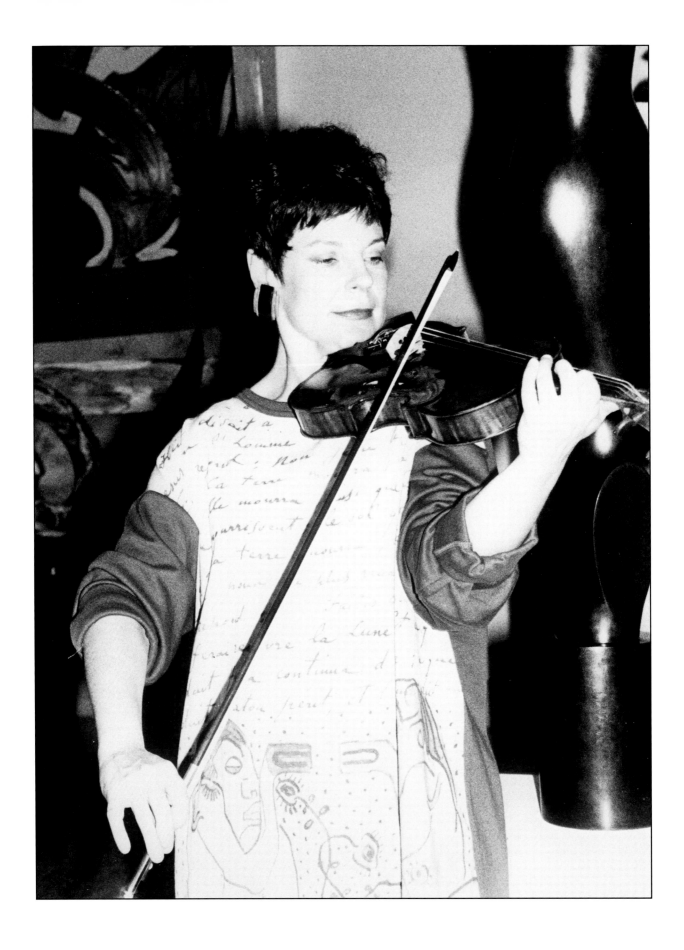

# CAROL Sindell

## violinist

*"I've never separated my life from my music."*

The bow is the brush and the violin, the canvas through which Carol Sindell creates her art. To the composer's score she adds impeccable technique and a finely honed musical sensibility. A gifted violinist, Sindell sees her challenge as communicating the composer's intent but with an emotive response that brings her into the creative process.

Sometimes the response, or interpretation, must involve others, and Sindell, who is the violinist in the Florestan Trio, enjoys the interaction within the group, not only in defining the interpretation but also in the selection of repertoire. Harold Gray, pianist, and Hamilton Cheifetz, cellist, are the other members of the trio, which performs throughout the country and abroad, as well as at its home base, Portland State University. Included in their repertoire are compositions written especially for the Florestan by Oregon composers, Bryan Johanson and Tomas Svoboda.

The trio was formed in 1977, when Sindell and Cheifetz arrived from Wisconsin and Gray, from Chicago, where the three had met and played together on an informal basis. All three are now members of the faculty at PSU, which offers them a base and they, in return, act as ambassadors of good will for the university. Their performing tours in 1989 have taken them to Japan, Cleveland and Chicago, as well as to small towns in Oregon that rarely have the opportunity to hear chamber music.

Sindell's career as a solo performer began in 1959 when, at age 11, she made her debut with the Cleveland Orchestra, playing the Mendelssohn concerto. The music critic for the Cleveland *Plain Dealer* wrote in his review of the concert: "...Her playing was close to the miraculous and the incredible. The manifestation of such God-given talent, so admirably trained, was something to bring tears to the eyes. Not a note was dropped, even in the swiftest and most difficult passages, and the pure lyricism of her evenly controlled bowing was heart-melting...The tone of the half-pint-size violin was, of course, small, but it was never covered and soared to the most astonishingly authoritative climaxes."

As a toddler Sindell could sing in pitch and pick out nursery songs on the piano. Joseph Gingold, concertmaster for the Cleveland Orchestra, became her first teacher, and at age 13, when her family spent a year in Los Angeles, she was accepted as a student by Jascha Heifetz. Her parents saw to it that she was not exploited as a child prodigy, however, and that her education and family life were not neglected.

She studied at Julliard and at the Oberlin Conservatory, where she earned her degree. She taught at Baldwin-Wallace Conservatory in Ohio and later at the Wisconsin Conservatory in Milwaukee, before moving to Portland in 1977. "Teaching is part of my lifeblood. I really do thrive on it and learn so much from students."

As a teacher, she must criticize; as a performer, she must accept criticism. And like all performers, her feelings are mixed about the relationship of criticism to performance.

"I'm not nearly as sensitive about it as I was when I was younger, and at this point in my life, I'd like to learn; I'm curious. However, I also like untutored opinions. I like audience reaction, especially in small towns, where people tend to be more open and less biased." Nonetheless, she prizes the good reviews by critics, especially those she has received in New York.

"I've never separated my life from my music. I take time off occasionally because it's necessary to nourish one's self with other artistic vitamins, but not for long. I would play my violin even if I never had an audience."

Photo: D. Thornton/Text: L. Allan

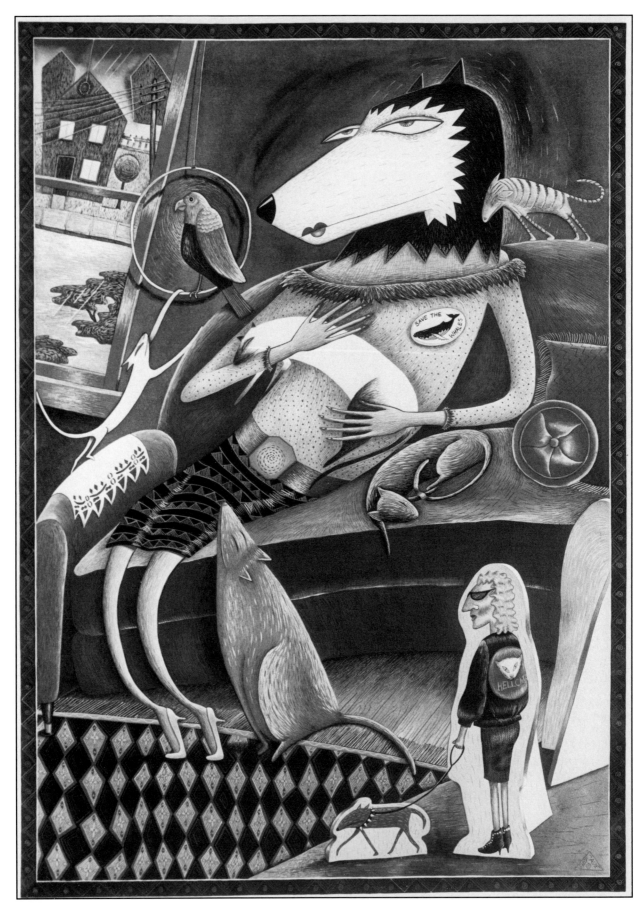

*Save the People*

*"I like the use of animal imagery because it couples the human-like nature of animals ...with an otherworldly quality."*

# CLAUDIA
## Cave

*graphite drawing
gouache painting*

Claudia Cave's unique drawings and paintings are just that: uniquely Claudia Cave — her thoughts, emotions and state of mind — as she develops each very original work of art.

"I am interested in many things when I approach my work. Such as: Is it interesting visually? Does it pique the viewer's curiosity? Does it have a point of view or even no point of view, acting as a catalyst to thought? Does it have the ability to bring the viewer back for a second, third, or even fourth look?

The imagery that Cave uses is always changing, even as she is always changing. One constant in her work is the use of animal imagery, especially the dog.

"I like the use of animal imagery because it couples the human-like nature of animals (or animal-like nature of humans) with an otherworldly quality." Often an animal head is attached to a human body, thus clouding the separation of human and animal even more.

Cave's early work was in black and white, using graphite. "I didn't have the space or money for other media." She then experimented with different styles and media, concentrating on individual development. Color expanded her knowledge as an artist, as she began to work with gouache (opaque watercolor), thus adding another dimension to the imagery she was using at that time. Gouache seemed to her to be like moving into enchanted territory.

"I think I am easily bored, so I look for new ways to expand my work. Recently I began painting on black paper. I love the deep, rich colors from working on a dark surface. It is very different from painting on a white surface in that every color seems light next to the black,

and so I am forced to work darker, and in many ways, bolder."

She works intuitively, from her own images and from what is happening in her life. She feels that the work of any artist is a meshing of that individual's own life and experiences with the history of art and all that came before. Her dogs are kinder and gentler now, she says, as she matures.

"The '60s and '70s were a difficult time to grow up, for not only external but internal things, and one needed to work this all out."

Often her work is a commentary on people, places or things in the external world. Other times her work reflects an inner life of pure imagination.

Cave holds a master of fine arts degree from the University of Idaho. Her work is in numerous public collections, including the University of Oregon science complex.

"Whenever I think of some image or idea that seems a bit far-fetched, or even bordering on trite, rather than discounting it, I charge ahead, hoping that I can pull it off. I'm not always sure that I do, but I'm afraid that if I become too careful, I will miss something exciting!"

Photo: D. Thornton/Text: D. Thornton

# *MARIE*
## Lyman

### *mixed media*

"The work that I do is abstract. It's not figurative, and in a sense, it's a true collage of lots of materials and forms put together to make a whole.

"In many ways, I feel blessed with that way of working: even though I may be dealing with very dark issues, the process is the most important part, and even though there may be a lot of pain in making the work, the end result is that it's something the viewer may enjoy looking at," says Marie Lyman.

Lyman builds on the affinity between fine, handmade paper and fine textiles in her pieces. Though she uses up to seven layers of translucent papers, washes and fabrics in each mixed media piece, the work remains surprisingly thin because the materials are refined. Though her current work is in mixed media, Lyman began 15 years ago making pieces inspired by American quilts.

Lyman's work is intimate in size, a result of having lived in Japan on two occasions between 1980 and 1985. "In Japan, there is not a lot of room so you have to work fairly small." Most of her pieces are two by three feet, the standard dimensions of Japanese paper.

*"...the work that I do deals with the issues of my life ... some of those are feminist issues and some of them are human issues."*

Her Japanese hiatuses, sponsored by grants from The National Endowment for the Arts and the Japan Foundation, allowed her the time and distance needed to make crucial decisions about her art.

While she feels she would have made those decisions anywhere, "Being in Japan was a lot like coming home. There were things my own culture didn't validate (such as her choice of a subdued palette) that Japanese culture did."

Cryptic titles allow the viewer to find individual meaning in her pieces. In some cases, the viewer "may be appalled" at what she was thinking of while doing the work. "It isn't that my work is so black. I trust the viewer very much not to see what I see in the piece but to see what they need to see in the piece.

"I think the most important thing is that the work that I do deals with the issues in my life ... some of those are feminist issues and some of them are human issues. It's a sort of journey: pursuing the work of a human being rather than just being man or woman."

In 1987, Lyman received an individual artist fellowship for "The Cancer Project" sponsored by the Oregon Arts Commission. The show, opening in February 1990 at Marylhurst College, explores issues relating to cancer. Lyman had breast cancer five years ago. "One of the reasons I wanted to pursue this project is that I do work in abstract terms and there are issues in cancer I need to be more explicit about."

Like all her work, "I feel it's part of the healing process ... It isn't that every piece has such a profound effect that you achieve that goal you're seeking, but those are the ones you strive for."

Photo: D. Browne/Text: M. Fisher

# MARTHA KAY
## Renfroe

### *fiction writing*

Friendship defines her fiction and her life. That definition has culminated in a book, *A Gift Upon the Shore*, that Martha Kay Renfroe — pen name, M.K. Wren — views as her best. *"Gift* has been my obsession for a while. It may be the best thing I'll ever write."

Set in the near future, the book struggles with the compromises women must make and how important friendship is to them. Two women, Rachel and Mary, survivors of a nuclear holocaust, find their own way of preserving civilization by scrounging books. Their friendship and common goal are threatened

> *"It's a pleasure being in a world you created. I think most writers are evangelists: they have something to say."*

when they are confronted with the charismatic leader of a religious commune, who views only one book as valid. The friendship is tested when Mary, years younger than Rachel, chooses to have a child and becomes separated from Rachel. Later, a young man, chosen as heir and keeper of the books, becomes the focal point of conflict.

The friendship between the two women, paralleling Renfroe's own deep friendship with Ruth D. Grover, made it difficult for her to separate Ruth and herself from the characters. Dialogue for the character Mary was hard at first, Renfroe said, until Renfroe ceased being Mary. The process was more difficult with Rachel, the character like her friend, Ruth, but she finally separated the two.

Taking almost four years to write, *A Gift Upon the Shore* has become the high point of her career. But the book went through six drafts before completion and was cut almost in half, from first draft to last. "I was trying to get everything I believe and hold precious in this one book."

Seated at her kitchen table overlooking the ocean, one can see why her books are set on the Oregon coast. But for Renfroe, those settings have become not only the place where she lives and which her readers love to hear about. That setting became vital for *A Gift Upon the Shore* because Renfroe feels the environment in a coastal region is more likely to rebound from a nuclear explosion. Creating the literary effects of a nuclear war, trying to determine how lasting the effects would be, led her to much research and thought. "You look around and see how fragile everything can be."

Renfroe, who began her professional career as a painter, understands the compromises that women make because of those she has made in her own life. Unable to make an adequate living as a painter of miniatures, she began to write to supplement her income.

She wrote her first book, *Curiosity Didn't Kill the Cat*, which features the character she calls her alter ego, Conan Flagg, and submitted it herself to Doubleday. She gradually quit painting to write full time. She has written six Conan Flagg mysteries and is now working on her seventh.

"I miss the painting because it's very sensual and it's very physical. It's very pleasurable. You don't get that from writing; it is a very intellectual pursuit. Everything is in your head."

Great pleasure, however, is derived from creating a world and populating it with characters and events that make people laugh or cry.

"It's a pleasure being in a world you created. I think most writers are evangelists: they have something to say."

Photo: R.Grover/Text: P. Hartwig

# LUCINDA Parker

## *acrylic painting*

Only a few of the many admirers of her paintings know that Lucinda Parker is a singer as well as a painter. That's because singing is a private pleasure, but one of great significance to her art.

"I think of my paintings as visible songs," she says. "Just as in good music — rhythm, volume, repetition and themes are the components of good art and can be used over and over without getting stale." As in a Bach fugue, a theme or figure that is central in a Parker painting can be found in many permutations —upside down, reversed, played against sub-themes, colored by harmonies — but finally resolved within its basic key, or structure.

Although her paintings are predominantly abstract — and, indeed, she refers to herself as an abstract painter — Parker frequently uses an image from nature, such as a fish or a snake, that can be treated as a visually dynamic shape but, at the same time, projects symbolic power. The image is incorporated into a maelstrom of brushstrokes, and even though it is distinct, there is a tension between it and the charged field behind it. Color, too, plays a major role in the high-energy level of her work and is orchestrated to establish mood and to define design and structure. Its direction and weight as carried by the moving brush provide a sense of gesture that keeps the eye moving, traveling through every part of the composition. More than most colorists, Parker uses black, both for its modeling force and to turn the form. The combination of dynamic gesture, vibrant color, tension between figure and ground requires a Parker's virtuosic control to maintain a balance between chaos and order.

Like the abstract expressionists of the 1940s, Parker sees painting as a physical as well as an intellectual activity.

The physical aspect is in the crucial importance and individuality of the brushstroke. "It is," she says, "a metaphor for water in its fluidity, speed, volume and force."

It is also a visible, dramatic record of the artist's presence. The cool impersonality of much abstract work and also of the Pop period — Andy Warhol's soup cans, for example — is not for her. The passion she feels both for the medium and the process is inherent in the finished work. She recognizes the associational and intellectual

> ## *"I think of my paintings as visible songs."*

force of images and symbols and uses them to convey several layers of meaning. The fish and snake, for example, occur in the religions and myths of many cultures — so many, in fact, that they are archetypal; we respond emotionally to their images without conscious comprehension.

As the daughter of a scientist and a musician, Parker grew up in a family in which intellectual and creative ability were valued and nurtured. Her academic studies took her to Reed College and the Pacific Northwest College of Art for undergraduate work and to the Pratt Institute for a master of fine arts degree.

A love of literature and nature, as well as of music, feeds the inner sources of her art. References to these interests are found throughout her oeuvre, not only in images but also in words and phrases that appear, sometimes in a border or a frame, sometimes in the body of the painting. The brushstrokes that form words carry the same visual immediacy as the other elements, and in addition, the extra dimension of language. Usually, literal meaning is ambiguous, or at the least, elusive, but in one instance, it is quite clear. In the huge painting created for the Oregon Convention Center, swirling fish, water and color forms are surrounded by borders that include the names of all the rivers in Oregon.

"Whatever causes you to make a painting must come from inside," the artist said, "and you have to have a passion for it or it won't be any good." Memorable art like Parker's comes from a deep wellspring of both passion and intelligence.

Photo: D. Browne/Text: L. Allan

# *JEAN* Auel

## *fiction writing*

"What the hero of the story is doing is what the reader identifies with. It doesn't matter whether the reader is male or female," says Jean Auel, author of the *Earth's Children* series.

"I'm a feminist, but I'm not trying to write a feminist polemic. I'm trying to write a story that all people will enjoy." As a child hooked on fairy tales, Auel "always identified with the male protagonist" because men had the active roles. In Ayla, she found her female hero.

Writing never occurred to Auel when she left Tektronix in November 1976 after 11 years of employment there. One day the following January, "this idea kept coming around — this girl living with people who were different, who were physically not as developed. I knew I was thinking pre-history. But I wasn't even sure it was real."

That night Auel sat down to see if she could write a short story. She enjoyed creating characters and scenes but was frustrated by not knowing how early humans lived. Her prodigious research began.

Nearly a half million words later, Auel had what she thought was a novel in six parts, titled *Earth's Children*. "The major story elements were there, but the love and passion I was feeling were not on the page." She went back to the library and got books on how to write fiction.

Now at work on the fourth of six books in the *Earth's Children* series, what has kept Auel's confidence in her story is "that these people were human." The human element that came up the strongest for me, even in doing research, was emotion."

Compassion, evidenced in the skeletal remains of a Neanderthal man, upon whom Auel based her character Creb, was present in humans' earliest beginnings. The man died of old age, but the atrophied bones in his skeleton indicated severe injury and possible partial paralysis in his youth. He lived because others cared for him.

Issues of gender and equity are ongoing themes throughout Auel's books. That fact,

> *"The human element that came up the strongest for me, even in doing research, was emotion."*

coupled with the degree of culture she describes, causes some readers to think her work is anachronistic. As the mother of five and grandmother of 13, Auel is sensitive to both the male and female condition, but she doesn't feel that fact gives her the right to take scientific liberty.

"One of the reasons a novelist does research in the first place is for the sake of the story." She believes for readers to accept a story's integrity, a novelist must care enough to see that its factual elements are correct. Auel's insistence on accuracy has taken her to archeological sites around the globe and provided her entree to the world's pre-eminent archeologists and anthropologists. Her personal reference library now contains over 2,000 volumes.

Her depiction of the time period and daily life is in keeping with newer scientific views. But, unlike scientists who can examine competing theories until one theory bears out, novelists "have to make choices ... one of the ways I do so is very subjective: 'Does it feel right?'" After reading about a dig where several small but disparate objects were found together, Auel speculated their common characteristic was that each had great personal significance for its owner. From that, the idea for Ayla's amulet took shape.

Auel admits there is "not a scientist in the world who would agree with every speculation I've made," but her exhaustive research has given her credence with the scientific community.

During 1989 Auel gave the keynote address at the World Summit Archeological Conference on "The Peopling of the Americas," held at the University of Maine, and spoke at the "Circum-Pacific Pre-History Conference," another worldwide meeting, at the Seattle Center, as part of the state of Washington's centennial celebration.

Photo: C. Cheney/Text: M. Fisher

# ELIZABETH
## Mapelli

### glass installations

abuse and involve them in the realities of the art, she photographed each worker with an instant camera, then tacked the snapshots onto a bulletin board with their comments. By the time the installation was in place, she recalls, the guys were bringing their families down to see the work and to look at the bulletin board.

Thanks in large part to the increasing availability of state tax dollars designated for art acquisitions — such as Oregon's 1 Percent for Arts — more public commissions are available. Although there are, in turn, greater numbers of artists seeking those dollars, Mapelli's years spent perfecting her techniques give her a leading edge. Even so, it's a feast-or-famine existence. Part of the nature of competitive commissions is a lot of rejections.

But Mapelli has always been a risk-taker. A

---

*"Play as hard as you can, work as hard as you can, do what is important to you."*

---

Liz Mapelli's glass installations present a kaleidoscope of vivid colors, the result of fine-tuning techniques in fused and enameled glass. Mapelli has developed a number of techniques herself, such as enameling glass — a glazing technique — and led the way in large-scale glass installations on which her reputation is based.

Her current work is predominantly architectural and has taken on a more painterly and more narrative style than she used previously. An example is the Portland Convention Center installation, incorporating photographs of places around Oregon. Words have also begun appearing with the glass — sometimes Mapelli's own words, sometimes those of others. Community projects lend themselves well to that melding of ideas and art, she notes.

She applauds the increasing use of and funding for art in public places. "The arts bring so much to people in the workplace and bring dollars back into the community."

But with her first big installation — completed in 1982 and occupying 5,000 square feet within the Portland Justice Center —Mapelli found the first viewers (workmen hired to install the pieces) were not convinced of either its aesthetic or economic merit. To counter their verbal

single mother at 22, she chose to turn full attention to her art as a living in order to accommodate her young daughter in her studio.

"When she was growing up, we used to spend hours and hours in my studio together — she'd help. I spent a lot of time working; I had to. Things were pretty thin..."

Today her artistic accomplishments bring tens of thousands of dollars. Risk is integral to Mapelli's style. "It doesn't always make life easy for those around me. I guess I need risk in my life." An avid traveler, she has for years pushed the limits of both life and art. "My experiences traveling have certainly influenced my work in both color and design and how they relate to the architectural elements.

"Follow your heart with your work. Don't hold back. You'll be sorry later. Play as hard as you can, work as hard as you can, do what is important to you."

Photo: D. Browne/Text: E. Nichols

# FERNANDA D'Agostino

## mixed media installations

> *"We interpret differently based on our own life experiences."*

Nanda D'Agostino's mixed media installations are heavily laden with symbols that appear repeatedly through time and varied civilizations. Every piece is carefully crafted and holds personal meaning for her. But she is reluctant to share her own interpretations.

"I want to avoid saying any one piece has a specific meaning. I've tried to present a visual symbol that has associations for everybody. Some may be more profound, depending on who is looking. I want people to feel how they feel when they leave a dream. We interpret differently based on our own life experiences."

D'Agostino's roots run deep into her Italian heritage. From it she's drawn both knowledge and understanding of history, a sense of unbroken culture, often absent in the youthful and heterogeneous American experience.

*LaConscenza della Nonna (The Knowledge of the Grandmother)*, D'Agostino's first installation, was a tribute to her grandmother, who emigrated from Italy in 1900. Begun after D'Agostino's own first extended visit to Italy, her pieces show the influence of both ancient and modern architectural aspects of the country, as well as the conventions of Italy's wayside shrines, incorporating female iconography. Coupled with special lighting and sound, mixed media became multimedia.

"I wanted to create a history for myself in America. There, the surface is modern. But through the window of a 400-year-old building, you can see someone working at a computer; and the building is sitting on a 1000-year-old Etruscan foundation. You can see how civilization developed."

D'Agostino, raised in Philadelphia, was drawn to Montana's hippie lifestyle. She taught kindergarten there and experimented with avant-garde artistic expressions, first through evening ceramics classes, then becoming a master of fine arts candidate at the University of Montana without benefit of an undergraduate degree in art. It felt a bit like "coming in through the bathroom window," she recalls, but it provided an opportunity to study with several famous artists who had immigrated to Montana for many of the same reasons D'Agostino had. It was a time to try the unconventional, the unexpected.

Installations take hundreds — sometimes thousands — of square feet of space and many months of work, to be placed on display for a brief time. D'Agostino equates the process with working for two years on scraps of paper and being given one day to put the whole picture together. With the design of each installation she has mastered another art form: clay, felt, carpentry, copper foil. Each element stands on its own, at once self-contained, yet impacting and enriching the whole, as individual experience has enriched civilizations.

With *Offering*, her third installation, D'Agostino has further refined the Italian imagery, simplifying, paring down the symbols, creating a tighter, cleaner, more hopeful impact. Spiritual without being religious, the installation provides the viewer a setting both contemplative and reflective.

"Though I'm scared about all the (negative) environmental things going on, I have to feel hopeful for the sake of my daughter. I want to pose questions to people that will encourage them."

Photo: D. Browne/Text: E. Nichols

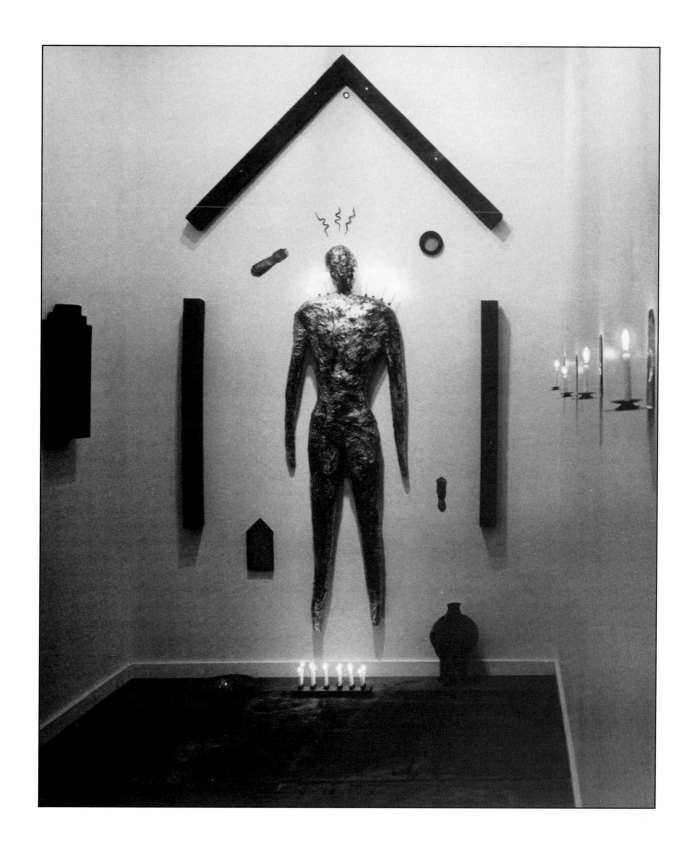

*Offering*

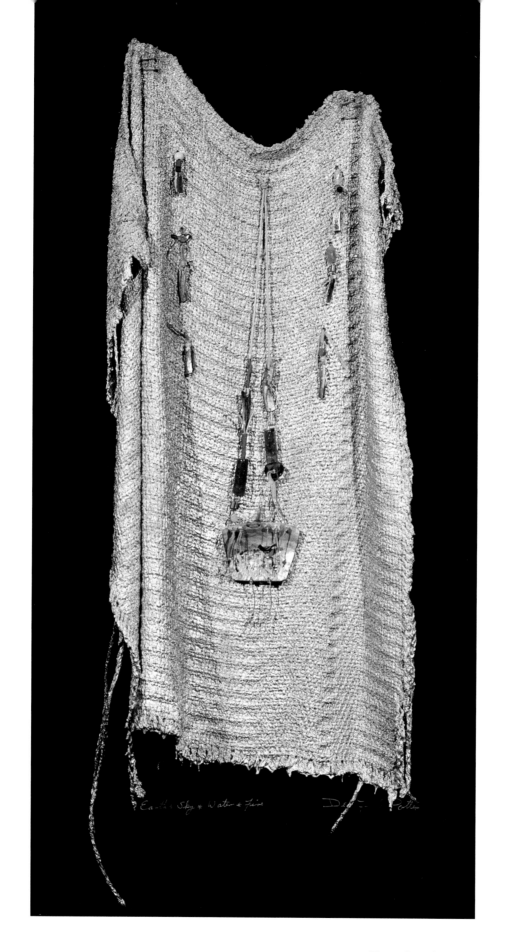

*Earth - Sky - Water - Fire*

# *DEE*
## Ford Potter
### *sculpting/weaving*

*"...all artwork is a soul-searching expression..."*

"I've always known I would be involved in politics, but I was never sure what form it would take. The statement seems to be in my artwork and my feelings of caring about what the world is and what its future is," says Dee Ford Potter, weaver, printmaker and sculptor.

She credits her political bent to the influence of her two grandmothers, one a suffragist, the other the first woman to join Future Farmers of America.

In women artists Potter finds a "sensitivity to humankind and the emotions. It's like a sharing of the soul rather than a projection of power." It's the women, she feels, who are creating new art forms by using fluid materials, such as fiberglass and glass, in their work; treating fiber as sculpture; using curved rather than angular lines; combining art forms, such as stitchery and chine colle', and bringing household items into their presentations.

"In a way it's somewhat like the Impressionists, who got more personal in their presentation and subject matter." Her own work is testimony to her observations. Using resin and glue she has molded her weavings into fluid, painted sculptures. "I started thinking of them as ancient, ceremonial pieces."

Thoughts of ancient people, especially the women, and how they went about their daily lives provided inspiration for a group of weavings she calls the *Cradle Blanket* series. A piece called *The Ancient Ones* won the Umpqua Valley Arts Association Western Art Show painted woven sculptures competition.

In 1986, Potter was one of 22 artists selected nationally to visit mainland China as part of the People-to-People Ambassador Program. While there she was asked to return and teach at the University of Shanghai fiber design department, an offer she may yet pursue.

Being an artist is a process of self-education,

Potter believes. When she began her printmaking in 1986, female faces emerged. Recently, her first male face, distorted with anger and fear, came out in a print. "It scared me." She is still not sure what it means, but notes that "all artwork is a soul-searching expression, and evidently it's part of my soul."

She has created a transition from weaving to printmaking by using her weavings in the creation of her prints. One weaving can provide as many as eight generations of imprints. The first imprint is created by laying a weaving on an inked plate. Then the weaving is removed and the first print made on the plate, showing the area where the weaving was as white space, the weaving having absorbed the ink on the plate. Subsequent generations made from the inked weaving pick up the textural details of the weaving, down to the wisps of thread.

Potter sees connections in art forms and tries to build upon them. She has most recently begun making metal sculptures and finds they provide a perfect antithesis to her work. While the challenge in weavings is to give them form, the challenge in metal sculpting is to make the metal appear soft and fluid.

Photo: M. Fisher/Text: M. Fisher

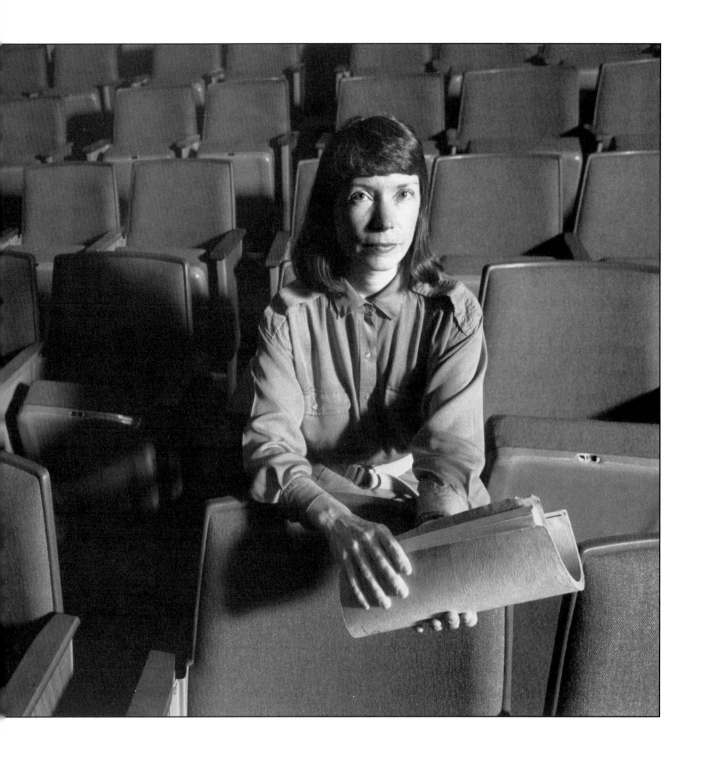

# DOROTHY Velasco

## *playwriting*

Conflict, "they" say, builds the tale. Playwright Dorothy Velasco couldn't seem to get the hang of it — at least not the conventions then being taught in her college classes.

"I like to avoid conflict in life, instead of letting characters tear at each other's throats," Velasco says. "I'm always trying to find a compromise. In critiques, I was always told there was not enough conflict in my plays."

Not until she attended her first national women playwrights conference did she learn that there was a new way of critiquing women's plays, that women often do not envision conflict in the same way men do, that her writing style was appropriate, accurate and vital.

Velasco believes in giving her audiences a theme of tolerance, "a wonderful shared experience, as in an ancient Greek stadium," she explains, "coming together for purposes of betterment. I'm optimistic enough to want to see if we can't improve ourselves a little bit; it comes from being a part of our community.

"An artist can easily fade back into the mind and not be a part of what is going on around her," Velasco points out. "I like being in my community. I want to be aware of what people are feeling so that I can filter that through my art — through my writing."

Writing has been an obsession with Velasco since she was 15. But she sees herself as part of the audience rather than as part of the characters. "It's thrilling to be a part of the audience; I always laugh and cry harder than anyone else. It's that communication, that feeling of communion with those people."

Velasco was a drama major in college, but soon realized she was not public enough to "get on stage and spill my guts. But I loved the thrill of the theater. So I decided to become a playwright and let others get on stage and spill their guts for me."

Success is not measured through a Broadway production, she believes, but rather a lot of fine productions in established, regional theaters. "Broadway plays are not necessarily as serious as those done in regional theater."

*The Northwest Woman* is a collection of character portrayals Velasco wrote some 10 years ago, a major step that introduced her to historic writing, creating with factual substance. Through the vignettes she shares a woman's conflict within herself and with the world in which she lives. The one-woman show has been much performed by Eugene actress Jane Van Boskirk at schools and colleges, regional theaters and special events.

"I am a feminist, so I will always try to write wonderful roles for women. I think they have been shortchanged in the past."

Velasco went to Mexico in 1968 to perfect her Spanish. She wound up marrying and staying for eight years, teaching theater and writing. She even started a NOW chapter in Guadalajara. Her two children were born there.

Although remarried and living in Springfield now, the ties with Mexico remain. She has an admiration for the culture and a respect for the endurance of the people, she says. Her understanding has lent strength to a documentary she

> *"Every play is a step further along in my art. I don't expect ever to be satisfied, because then I will stop trying."*

is scripting and co-producing, *Daughters of the Land*, which will air early in 1990. The program examines the health, education and living conditions of Hispanic migrant women and their children. Another independent production Velasco wrote and co-produced, *Railroad Women*, won a documentary award in 1988.

Velasco is anxious to move beyond non-fiction into a more experimental style. "I'm ready for a personal, fictional exploration of emotions. Fictional plays are more satisfying because I'm completely in control of them," she says. "It's a totally creative process. Every play is a step further along in my art. I don't expect ever to be satisfied, because then I will stop trying."

Photo: T. Hendrix/Text: E. Nichols

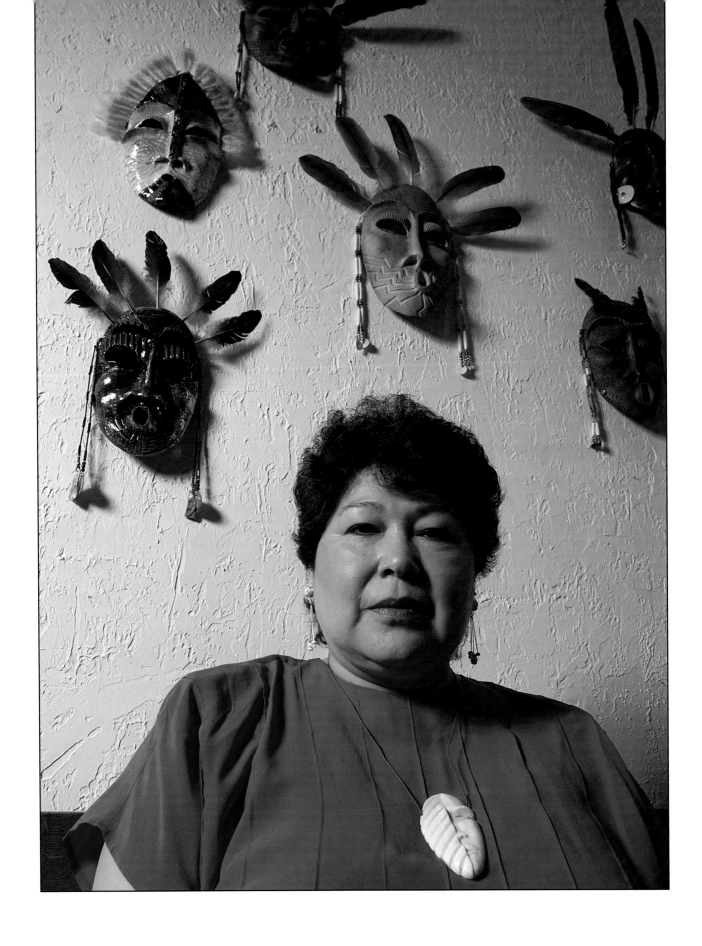

# *LILLIAN* Pitt

## *clay masks*

A long time ago, so the legend goes, there was a woman chief among the Columbia River people who excelled at teaching her followers how to live well. Because she wanted to watch over her people forever, Coyote changed her into a rock, and now we feel her presence and her enduring strength in our daily encounters with rocks everywhere, in fields, streams and mountains.

A representation of the woman chief is found in the pictographs of the Columbia River Gorge. It is the inspiration for Lillian Pitt's Anagama mask, *She Who Watches*. This mask, as well as *Feather Woman, Bird Woman* and *Spider Woman*, commemorates the artist's love and respect for the generations of women in her family who were part of the Warm Springs Confederated Tribes. "No matter what their hardships were, they persevered; they built and rebuilt their abodes and took care of their families, and at the same time, they carried on the cultural traditions and values of their people," she said.

Like many artists, Pitt uses her art as a vehicle for her responses to social and political issues as well as to convey emotions. The devastating fire at Yellowstone National Park in 1988 with its loss of animal life brought about a series of animal masks that were a special satisfaction. Through the fire in the kiln, she was able, in a sense, to re-create life lost in the fire of the forests. Similarly, the Valdez oil spill of 1989 provided the context for memorializing yet another tragedy in nature, this time by creating otter and seal masks.

Lillian Pitt's career as a maskmaker began in a ceramics class at Mt. Hood Community College in 1981. Because of a back problem she was unable to work at the potter's wheel, and, as an alternative, the instructor suggested that she try working by hand. She rolled out a slab of clay, shaped it into a mask and knew immediately that she had found her own art form.

Today, her elegant masks are shown in museums and galleries from New York to California to Alaska. All of the masks begin with a clay face form. After glazing and firing, in either Raku or Anagama kilns, they are finished with additions of feathers, shells, beads or metal heishi. They do not follow a particular tradition (in fact, the Warm Springs tribes worked primarily in beads and baskets, not clay), but rather, are a blend of contemporary styles and techniques with the stark, simplified design motifs characteristic of Native American art.

Masks are among the most universal and ancient forms of the human, expressive spirit. Used in all cultures, they are identified with ritual and dance, with spiritual and magical forces, with storytelling and the passing on of cultural traditions. In Lillian Pitt's work, they retain an association with these primordial roots but are equally powerful for their beauty and embodiment of the artist's stated purpose: "I know it sounds like a romantic notion, but deep down, I wish my work would make everyone feel better."

> *"No matter what their hardships were, they persevered; they built and rebuilt their abodes and took care of their families, and at the same time, they carried on the cultural traditions and values of their people."*

Photo: T. Hendrix/Text: L. Allan

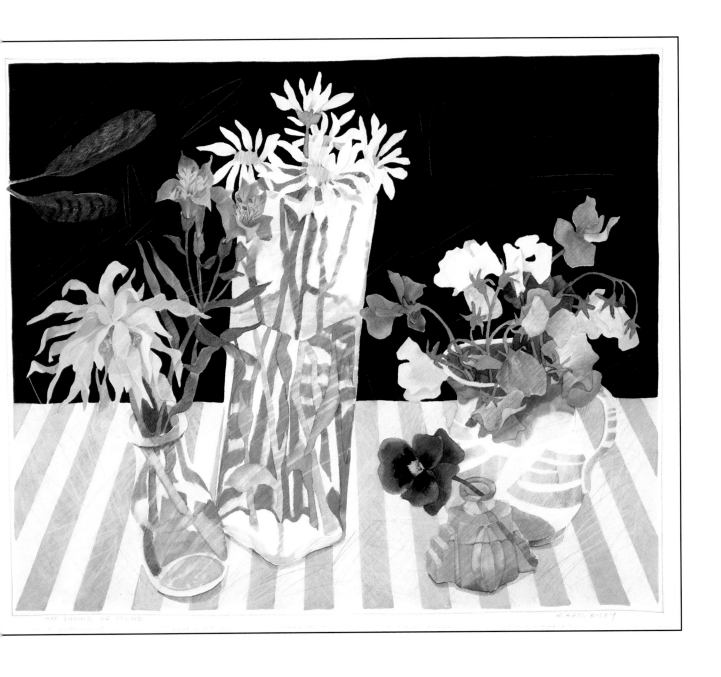

The Physics of Sound

# CAROL Riley

## *watercolor painting*

*"I come to know my subjects through drawing them first, establishing an intimate relationship before I begin to paint."*

Light, color and movement spill from her paintings, lending a feeling of comfort and yearning toward one another. This is the whole that we see from the little pieces Carol Riley loves around her, the things she cares about.

She is surrounded by what she paints: a little jar she particularly loves; a feather she finds from a visiting bird; flowers from her garden; a box of peaches, brought home by her husband — maturing to overripe in her studio before she paints them.

The flowers dominate many of her paintings. Though a commercial success almost from the time she began painting professionally, Riley admits it left her with a feeling that her peers might not take her work seriously. Early in her career she worried also about painting flowers — that people might think it too obvious. But she could not ignore flowers in her paintings, loving their colors and shapes as she does.

"Now I'm comfortable painting what I want," says Riley, reflecting on a personal journey through struggle to a place of trust and understanding. Trust, she explains, is incorporated into the technique she uses in her paintings. She paints the objects exactly first, perfecting the highlights and shadows. She then uses damp rice paper to rub out some of the perfection, which represents for her "a giving away of control." The result is that the imperfect portrayal of the object looks more like the real object than the perfect one did.

She likes to let the accidental happen, to let go of her ego. "I think it has a lot to do with trust — trusting that there is something bigger than myself working through me."

Encouraged by her parents, Riley became the class artist in grade school, but it wasn't until near the end of her college education that she decided to major in art. "It never occurred to me that I'd be able to make a living as a studio artist."

Her real success began when, with little ex-

perience, she convinced people she could paint murals in schools throughout the state for the Oregon Arts Commission. She would go into a school and work out a theme, with the children doing the drawings. Working at a rapid pace, a 90-foot mural would be finished by the end of a week.

Riley spends time getting to know what she paints. "I come to know my subjects through drawing them first, establishing an intimate relationship before I begin to paint." From the little glass jar to the box of peaches, this intimacy becomes evident. She brings her subjects to life, portraying their transitory and vulnerable qualities. They represent both the feminine and the masculine. Riley often emphasizes the feminine qualities in objects. Peaches, like flowers, have feminine qualities — fragile and vulnerable but still strong; solid and earthbound but lit from within. This light, evident in all her paintings, exudes the joy that Riley wants to share.

"I want people to have an entry ... my point in painting is to communicate."

Photo: W. Berry/Text: P. Hartwig

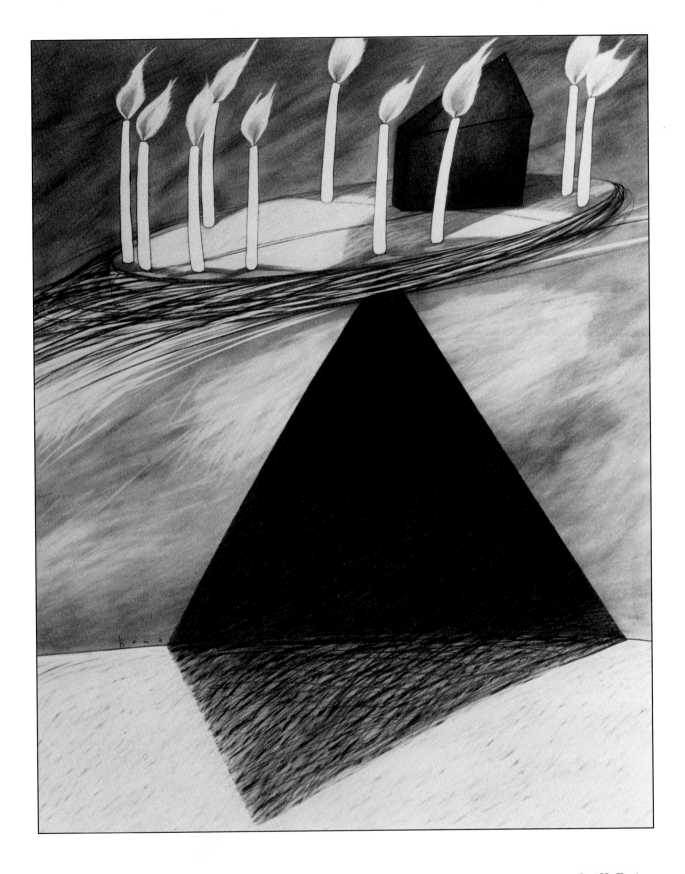

*Still Point*

# GEORGIANA
## Nehl

### *graphite drawing*

Pencils, paper and erasers. With these simplest of materials, Georgiana Nehl makes magical, ethereal drawings that are as much a revelation of the remarkable potential of drawing as they are of the evocative power of simple images.

Drawing has been defined as a coalescence of spirit and perception, the lean instrument of visual formulation and the vortex of artistic sensibility. The accuracy of that definition is certainly borne out in Nehl's current graphic work, although she herself has a more down to earth description of what drawing is to her: "I have a real love affair with the traction of dragging something across paper." More specifically, she continued, "I like the precision of graphite, the ability to get a hairline as well as a surface."

Her surfaces, built up of powdered graphite and pencil marks and lightened with erasures, are like a soft skin over the paper. The relationship of the images to the backgrounds, or fields, seems mutable, as if they are part of each other and might shift or even disappear.

Triangles, circles and spirals are ancient, primal images. As used in Nehl's drawings, they have personal significance to the artist but are universally meaningful in conscious as well as subconscious contexts.

In *Still Point* the plate form is simultaneously moving and still, anchored to the peak of the mountain. The plate is near, the mountain and field are in the distance. The light is strange; the shadow of the mountain, illogical. We have a feeling of great energy emanating from a still center. The plate, with its burning candles and mysterious object, suggests a ceremony, perhaps a celebration of life.

Although the complete congruity of these pieces hardly indicates it, Nehl begins each one, as she says, "randomly." "The process is intense; I wait for something to happen, for the piece to speak to me. If it doesn't, it gets put aside for awhile and I work on something else." Because the work is very personal, the process is a catalyst through which she searches for resolutions. Erasing, or "taking away," is as important as adding in order to achieve the end result.

Nehl is known for intricately detailed, complicated, delicately colored still lifes. These, too, are enigmatic and personal but much more grounded in the external world. They are hyper-

*"I have a real love affair with the traction of dragging something across paper."*

real in their precision and arrangement, so much so that evidence of the artist's hand in applying the colored pencil marks is almost nonexistent. The graphite drawings, by contrast, are vibrant testimony to her involvement in the act of creation — spontaneity versus control, precision versus diffusion, vision and revision — hiding nothing of its tactics. The eraser is as vital a tool as the pencil; it causes forms to emerge and light to flicker across the surface or to come from some interior source. Since 1978 Nehl has been on the faculty of the Oregon School of Arts and Crafts where she is now head of the Drawing and Design Department.

"Teaching, I think, has become an equal love to making my own work," she stated. "The direct contact with students to help them learn about themselves in the world as a part of their art is personally exciting. I love to see that moment of understanding."

Photo: D. Browne/Text: L. Allan

# JENNIFER
## Lake Miller

### *acrylic painting*

*"100 years later, I'm
painting America again."*

Jennifer Lake Miller took to art as a duckling to water, but it wasn't until she was an adult with a child of her own that she discovered the extent of her talent.

Miller grew up beneath her mother's drafting table. Her mother was a commercial artist and her father, a potter. Today, her parents' bird sculptures are displayed throughout the United States. Her great-great-uncle was famous American painter, George Catlin. And now, "100 years later, I'm painting America again." Though being raised in an artistic family gave Miller a chance to experiment with different art forms, her career as a painter began only three years ago. When she and her husband moved to Prineville, Miller became director of the Crook County Chamber of Commerce. She incorporated her art into her job in different ways, but it was a side project — a sign for garden products — that provided the turning point.

She painted the sign in a primitive style and sent a photo of it to her mother, asking "What do you think?" Her mother answered, "Start painting and don't stop." Gathering her courage, she took her mother's advice and quit the chamber job.

Though her paintings have been compared to those of Grandma Moses and Charles Wysacki, Miller considers her work unique in that she paints modern-day scenes in a primitive style.

"I studied all the primitive artists I could get my hands on. The problem is now, I am getting so refined, I'm becoming almost architectural."

Miller's first show was at her parents' gallery in Essex, New York. She painted scenes of the town from photos her parents sent her. When she arrived in Essex for her show and saw the town for the first time, "It was like walking inside my paintings."

It was an auspicious start; half of her paintings at the show sold. David Camalier, whose international Camalier and Buckley catalog offers Faberge eggs and other treasures, saw her work at the show and suggested she do primitive-style paintings of people's homes from photographs. The service would be offered in the catalog. She accepted and those commissions continue to be one of her mainstays.

The Essex series gave her the idea of capturing Oregon landmarks on canvas. Thus, her *Celebrating Oregon* series was born. When complete, the series will feature 12 scenes (that number was chosen so the paintings could be turned into a calendar) that visitors to Oregon can purchase and take home with them. To date, scenes of the Crook County Courthouse, Sisters, Mt. Bachelor, the Pittock Mansion, Heceta Lighthouse, Bandon and Ashland have been selected for paintings. The works begin as acrylic wall-sized paintings, which are then scaled down when printed.

Her paintings are peopled by those she observes, historical figures, caricatures of friends. Surprises, and what she terms her wacky sense of humor, pop out at the viewer. Examples of her whimsy are found in the *Celebrating Oregon* series.

Though her work is often described as primitive, she prefers to call it folk art or illustrative art: "folk art because of the colors and because it's whimsical. It's a matter of looking long enough." Her attitude toward life is imprinted on her work, says Miller. "This kind of work is extremely happy and my life is happy."

Photo: M. Fisher/Text: M. Fisher

*Sisters*

*"My work is concerned with place, and with the relationships between people and places; it mirrors my concern with the world, the earth, nature."*

# JUDITH
## Barrington

*poetry*

Judith Barrington has just returned from a week-long writers' workshop. Her house, she says, is full of boxes of food, books and papers, but she is not too busy to brew some tea and talk about writing and poetry and the things that influence her work.

A native of Brighton, England, Barrington has lived in the United States since 1976, writing, teaching and working for change for women.

"Virginia Woolf had a profound influence on me, perhaps because we both come from the same world, the same kind of countryside. I was always a kind of closet writer and reading her work gave me a perspective on women and writing. The poet Adrienne Rich is both a friend and an inspiration and has also helped me with my work a great deal.

"My work is concerned with place, and with the relationships between people and places; it mirrors my concern with the world, the earth, nature. I am fascinated with learning about poetry and with poetic technique and archaic forms."

Some of these forms, such as the villanelle, as well as syllabic poems, are included in her latest work, *History and Geography*. Barrington explores the history and geography of her own life and the themes of family history and relationships to places.

She has always been active in the feminist movement, both in England and the United States, and feels that windows have been opened on women's creativity, thus empowering women in their work.

"The women's movement started to free some powerful forces for women to be writers. I feel that the poetry written by women since the movement began is the most interesting major

work that has yet been produced."

With this in mind, six years ago Barrington developed the Flight of the Mind writing workshop for women, which is held each August on the McKenzie River near Eugene. "I feel a very strong commitment for the workshop to be a place for women writers; not just as a place to learn, but as a community, with a real sense of network. I want women to go away with a sense of belonging to a community of writers, a place where it's safe to explore one's own material, with teachers who will help you write like *you*.

"Showing your work to someone else, saying, 'I want to do this,' is to become a writer. After I left the women's studies program at Portland State University, I gave myself one year to be a writer. I made a serious decision to take on the identity of a writer. And when the time came to renew my passport and I had to write down an occupation — that's when I realized I *had* become a writer."

Photo: C. Borland/Text: M. Lowry

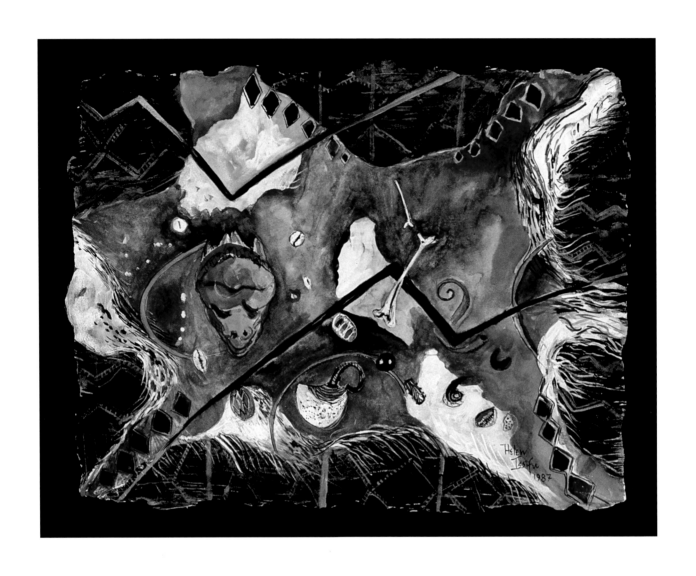

*A Late Night Fortune with Nabila*

# *HELEN* Issifu

## *watercolor painting*

Helen Issifu grew up in an Oregon household attuned to international interests and ideas. And her responses — both emotional and interpretive — are evident in her vibrant paintings. Nature's details and animal forms are coupled with the myths and customs of varying cultures.

Issifu's parents hosted a series of exchange students, from whom she developed an understanding of varying cultures and intercultural relations. She recalls her father participating in peace marches for civil rights.

"I try to involve myself in my own way in political and racial equity issues."

For a recent Blackfish Gallery exhibit on anti-racism and anti-Apartheid, Issifu created a large face — "any African woman — with deep eyes reflecting the death, violence and hunger that have been a part of the racial struggles for equality and justice."

When Issifu traveled to Ghana for the first time in 1978 to marry a student she'd met at Lewis and Clark College, she was struck by the intense visual overload of the African experience. As they traveled his country, she became immersed in their spiritual mythology and family traditions.

"Africa is very organic; I can relate to that. Although it is a Third World country — very poor — the people are very advanced socially. In the rural areas people are very close to the earth and growing things, and to their ancestors and spiritual needs. I liked their sociability and their close, extended families. Americans are kind of a lonely group in comparison."

Issifu's current exhibit works center on a series inspired by the theme of shamanism as practiced in Africa. Many of her paintings depict her interpretations of their herbalism and folklore that surrounds it.

Seduced by the opaque qualities and hues of watercolors, Issifu has developed a distinct style, using transparent paints, layering images upon and within images. Thick applications of paint are rubbed and added layers applied to achieve a luminosity.

Issifu also enjoys using beautiful papers, including a handmade, air-dried, 200-pound Twinrocker. Its deckle edge is frequently incorporated into Issifu's work, as in *A Late Night Fortune With Nabila,* where it almost becomes a

*"I try to involve myself in my own way in political and racial equity issues."*

part of the sheepskin mat on which a shaman throws out fortunes.

In addition to her African interests, Issifu has studied the art of other cultures, including those on the American continent. A more recent sojourn in the Southwest, near Santa Fe, has also begun to appear in her work, including her impressions of petroglyphs created by an early New Mexico culture. "They stretch for eight miles along the rimrocks. It deeply touched me, like a huge drawing board." One side, displaying men's activities, was evidently painted by men, she explains, while the opposite wall displays the activities of women and presumably was painted by women.

"For a period of time while I was married I did no art work. As a woman, I felt overwhelmed working full time, adjusting to relationships. During that time, I really suffered, because I had to grovel to get back up there (on top artistically) again. I've crawled my way back up."

Photo: C. Cheney/Text: E. Nichols

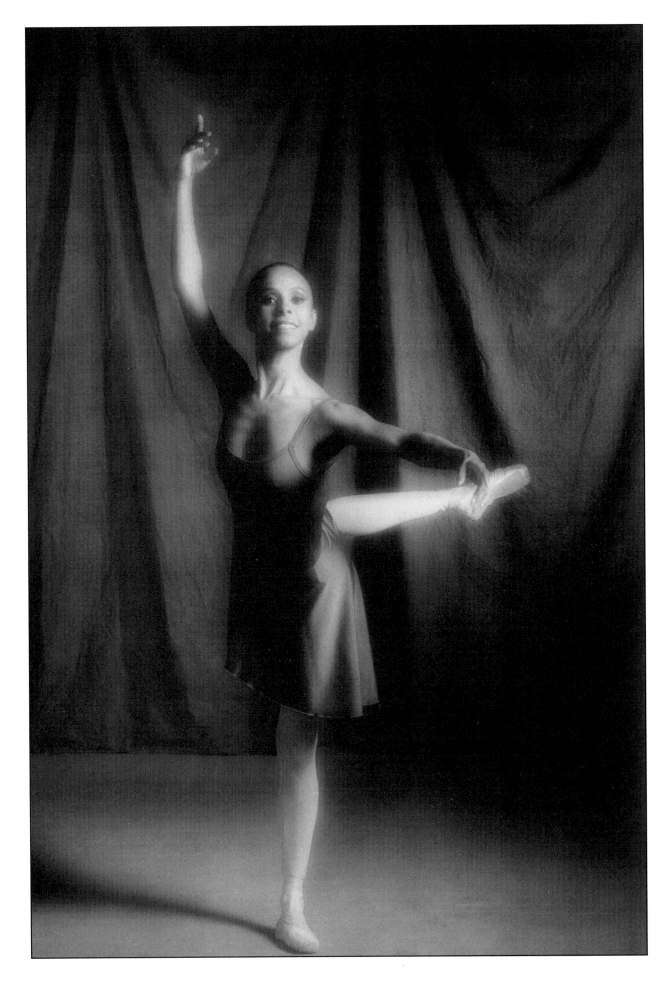

# ELENA Carter

*ballet*

"It's funny how things happen to change your life — destiny, I suppose," Elena Carter muses as she relates the circumstances that brought her to Portland. It was 1982, her husband had gotten a job at Jefferson High School and the couple planned to try a bi-coastal arrangement so that Carter could continue her career with the Dance Theatre of Harlem. Fate, however, intervened in the form of pregnancy, so she took a hiatus from dancing to accompany her husband. Although the marriage later ended, she has never regretted the move.

"Every artist has to be in New York sometime. But Portland is a much better place to live and, especially, to bring up a child." As a principal dancer with the Oregon Ballet Theatre and a teacher of ballet, both at the company's school and Jefferson High School, as well as a single parent to her six-year-old daughter, she appreciates the comparative ease of living in Portland.

When her formal ballet training began in her native Mexico City, Carter was almost 12, an age which is rather late, she feels, for serious preparation. In her case, it was not an irrevocable disadvantage. After high school, she entered the arts program at the Palace of Fine Arts, where she earned a degree in dance, which led to her acceptance by the National Dance Company of Mexico. When the Dance Theatre of Harlem came to Mexico City for an engagement, Carter asked Arthur Mitchell, its founder and director, for permission to take a class with the company. She so impressed him that he invited her to New York to join his company. The six years that she spent with the Harlem group were a rich experience of dancing, studying and traveling and did much to shape the maturity and individuality of style she brings to the Oregon Ballet Theatre.

Because of the potential for expressiveness, Carter prefers the dramatic roles of story ballets. "There are no words, so everything must be conveyed by gesture and movement — nuances become very important." She enjoyed doing *Giselle* with the National Dance Company of Mexico, and more recently, the role of Amelia in

> *"There's nothing I do where I'm more my real self than when I'm dancing."*

*The Moor's Pavanne* with the Pacific Ballet Theatre. Music, of course, plays an integral part in carrying both the action and the emotion of the story. Asked whether it is possible to dance without music, Carter replied, "I think not. Even though there is some choreography now in that direction, it seems to me that without music, you're talking about movement, not dance."

Even though the language and basic technique of ballet are universal, particular styles identified with countries, as well as with companies within countries, develop. Virtuosity of technique and romantic interpretation are associated with Russian ballet, while the United States is known for choreography that combines modern, jazz and ethnic dance with classical ballet. A young company, such as Oregon Ballet Theatre, develops its identity within this rich mix. It was founded in 1989 through a merger of the Pacific Ballet Theatre and Ballet Oregon and retains the director-choreographers of both former companies. Carter, who was a member of Pacific Ballet Theatre, sees new possibilities for expanded repertoire, as well as increased support and larger audiences that the merger will bring.

Teaching is as much a part of Carter's career as performing. Like all professional dancers, she anticipates the time when it will be the sole work. "It's very rewarding, but so intense. It's wonderful when you can encourage a student toward a professional career and terrible when you have to say 'no' to someone who wants it badly." For the present, she is fulfilled by an absorbing involvement in both aspects of her work. "Dancing is my best being. There's nothing I do where I'm more my real self than when I'm dancing."

Photo: C. Borland/Text: L. Allan

# MARGARET Via

## mixed media drawing

> *"I want the energy I see in a landscape to be a movement in my work."*

"I have always been interested in color, and landscape was the beginning." Living in the Midwest opened Via to the artistic possibilities in the vast, flat expanse. The shimmer that occurs when the chartreuse leaves touch the bright blue sky excited Via. "In the '70s I painted only hard-edge abstractions, but the impetus from them came from my response to nature."

After moving to Oregon 10 years ago, Via again began painting her surroundings. What many see as Oregon's liability became for Via an artistic asset. The enveloping fog and steady rains provided a filter for Via's paintings of luminous grey clouds.

A polio survivor, Via finds herself getting weaker as she grows older. "I used to stand up and brace myself and paint until I was shaking and had to sit down. I know all the time what a physical thing painting is. In fact, it is really a dance. You stand in front of the easel and you dance back and you dance forward — you are constantly doing that. As I grow weaker, I can't do the dance.

"I am stuck here close at hand to what I am doing. I think that can make me uptight and I have had to watch that. The thing that means so much to me is the gesture. There's a movement that has tensions and contrasts that I feel terribly excited about. I want the energy I see in a landscape to be a movement in my work."

Pastels have given Via a new medium for expression. She finds the immediacy they offer compatible with Oregon landscapes. She has also continued her use of India ink, graphite stick and a variety of pencils. "Even in a still life I want the page to seem large," says Via who creates the sense of space through her drawing.

Passion, sometimes conflicting in nature, has driven Via's life and art. A Southerner raised to believe service to others was above all else, it took Via several years to realize her art was a form of service.

"I had to overcome a guilt feeling. I would take out spaces of time, denying myself doing art to do these things I knew were the right things to do. I felt like art was such a selfish thing." She put aside her painting to work for civil rights, first in Atlanta, then in Madison, Wisconsin.

Though acutely aware of racial discrimination, the idea of sexual discrimination didn't occur to her until she was well along in her career. Like many women, Via felt professional success depended mainly on a willingness to work hard. "I just assumed I would develop myself." She completed her master's degree in fine arts and taught art courses for various ages. Today, Via meets regularly with a group of Eugene women artists to share professional concerns and lend support.

Despite interludes in her art, Via's interest in learning never abated.

Photo: C. Cheney/Text: M. Fisher

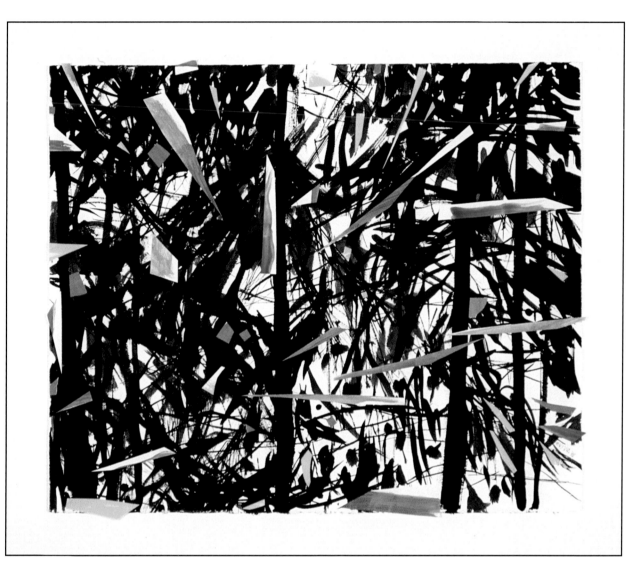

*Bach Woods*

# MARJORIE
## McDonald

*collage*

*"It has been a great blessing to me in my old age to be able to occupy myself with something creative."*

Gentle and inquisitive. Vulnerable and bold. In Marjorie McDonald's world, phrases are personified, dreamlike scenes glow with otherworldly colors, animals watch benevolently over their human counterparts.

Her collages are populated by figures "unlike any you have ever seen," born of her imagination. "Some call them beautiful. I don't call them beautiful. They are interesting and whimsical."

Her artistic career caps 40 years of service as a high school teacher. During World War II, when Russian soldiers were in Portland helping ship war materials, McDonald was one of a dozen teachers hired to teach them English. She, in turn, became fascinated with their language and persuaded school administrators to let her teach the first Russian language class ever offered in a U.S. high school. She later received permission from the Soviet government to spend three consecutive summers, 1959-61, studying the language and traveling unaccompanied throughout the country.

"I never had any thought of art until I was retired. I have suffered from extreme headaches ever since I was 50 years old. A friend told me that if I tried painting or (drawing) pictures it would help my headaches."

McDonald spent one year studying with a teacher who went through all the phases of art but included only two lessons on collage. "No one else in the class was interested, but I was because I like to work with my hands." She discovered that tissue paper, which the teacher recommended, went to pieces and that the colors ran when glued. She tried rice paper and she's used the material ever since, receiving most of her current supply from a former student now living in Japan.

When making a collage, "The first thing I do is dye the paper (most rice paper is white) in a solution of turpentine and oil paint. Then I dry it and when it is dry, tear it up in pieces." The technique, coupled with a predominantly warm palette, results in brilliant, engulfing colors and a surprising depth of field.

At first McDonald would paste the pieces on a board with no picture in mind. When the board was covered, she set it down and examined it from each side until she saw an image she wanted to develop. She now plans each picture mentally before sitting down to work.

"It has been a great blessing to me in my old age to be able to occupy myself with something creative. To be able to create something is a talent. How I happened to acquire it when I was 72 years old, I don't know. But I'm very, very grateful to be able to do it."

Now 91, McDonald continues to build a reputation as a regional artist. She is represented by the Schubert Gallery in Albany and the Jamison Gallery in Portland. Her works have also been displayed in the Rainbow Man Gallery in Santa Fe, New Mexico.

Photo: C. Cheney/Text: M. Fisher

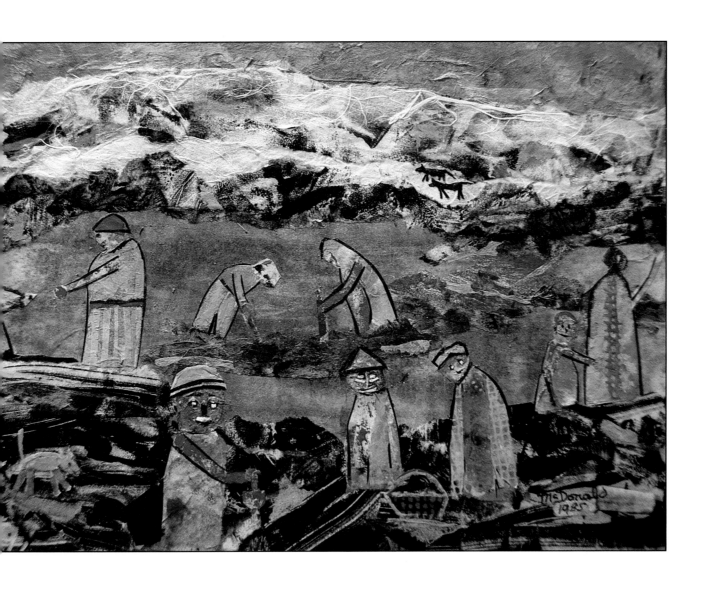

*The Treasure Hunt*

# SHARON Whitney

## playwrighting

*"I've learned I can move people and that's what I'm aiming for."*

Early in her career, Sharon Whitney opted for commercial success — economic validation — as a media producer and journalist. Living and working in New York City, she became addicted to credits and paychecks, Whitney recalls, a state in which she would never develop her own creative non-fiction.

She maintained an apartment in New York, even when living in Alaska with her family. Business took her east regularly and she found the cultural excitement stimulating and energizing. But in Alaska, Whitney also rediscovered the pleasures of community theater, in which she had acted and directed during her 20s.

Whitney completed the last of four books after she and her husband moved back to her native Oregon in 1984; then she began studying playwriting. She set a three-year goal to have a play completed and staged; she did two in that time.

"What I found was that I have had a lifelong habit of writing and thinking in dialogue. For years I thought I was going to work in film. But film, for a woman, means sacrificing everything. As bad as the odds are in playwriting for getting produced, the odds are even more difficult in film. Film is a total commitment. I don't want to be that obsessed — that I don't have a shred of family life or ordinary social existence left."

But she continued her regular trips to New York City for some years, enjoying the city's energy and the activities of off-Broadway theater. Those migrations are over now. Whitney has been successful in finding Northwest support and recognition. In 1979 her plays were being simultaneously produced in Seattle, Portland and Eugene.

Whitney initiated the Oregon chapter of the Northwest Playwrights Guild in 1987 to provide a network of regional support and increase the opportunities for local playwrights to develop their work in a positive atmosphere. The guild offers festivals, workshops and play-reading series. She's a member of the Portland Drama Critics Circle, previews plays for **Women InUNISON** magazine and produces and hosts *TheatreScene* on KBOO radio in Portland.

"This is what I want to do. I'm working in my own backyard. There's no reason to go back east; there's no point. Talent is everywhere — good actors, directors, designers and so on."

A part of Whitney's transition to playwright was accepting her need for a patron (in her case, husband, Phil Shapiro). Book and play royalties don't pay all the bills. Whitney also pursues competitions and grants as a means of getting her work mounted (performed).

"I've paid my dues; I've done work for good money. I have a lot of skills. I could earn (more) if I had to, or scale down my lifestyle radically. This is the life of an artist."

Several of Whitney's plays show women of differing ages claiming their independent voice and moving forward with new integrity, reflecting her own commitment to life's ongoing transformations. As she moves into more experimental territory, Whitney feels increasingly liberated from the "safe zone." Her characters evoke deeply felt emotions — anger, defiance, ecstasy — working satire from situations of exploitation. Audiences react strongly, sometimes bristling at the satire.

"I've learned I can move people and that's what I'm aiming for. Even if it scares me, I want to go deep."

Photo: R. Stefani/Text: E. Nichols

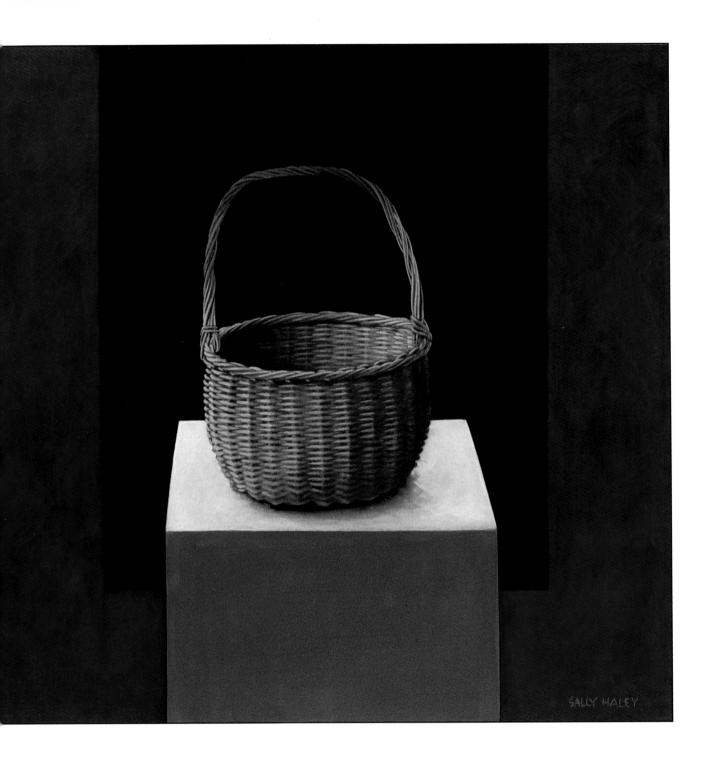

84

*"When you know them well,
they give you the ability to do
what you want."*

"'Tis the gift to be simple," from the old
Shaker hymn, *Simple Gifts*, applies to Sally
Haley's serene still lifes as well as to religious
practice. Many of her subjects come from garden
and kitchen: mixed flowers in an olive oil can,
green apples in a fluted mold, nuts in a basket.
They represent the enduring satisfactions that
make up the structure of our daily lives and hold
a history of the personal. Those familiar subjects
are shown on tables, shelves, boxes, or against a
color field; in all cases, settings that are as spare
and elegant as Shaker architecture.

Haley lives and paints in a big Victorian
house that is filled with furniture and artifacts
from many cultures, her own paintings and
those of her husband, Michele Russo. The two of
them met while students at Yale, where she
received a bachelor of fine arts degree in 1931.
"We found immediate rapport in discovering
modern art. At Yale, art history in those days cut
off even before Degas." After World War II, the
couple came to Portland where Mike had ac-
cepted a position on the faculty at the Oregon
Art Institute's Museum Art School. Sally main-
tained a studio at home, where she also brought
up two sons. She says that her work as an artist
has not been in the nature of a career but as a
way of life. "I work from an absolute need," she
said, "and life feels rather empty if that work
isn't there."

The style and themes that she has developed
over the years are an amalgam of her academic
background in traditional European painting
and art history, an assimilation of 20th-century
modernism and a love of medieval egg tempera
techniques. She sometimes paints what she calls
"performances," duplicates, as close as she can
make them, of icons or portraits from pre- and
early Renaissance periods. "I think of these as in
the same category as a musician playing Bach or
Vivaldi on a harpsichord, trying to reproduce the
composer's intent."

Egg tempera, the medium for these paintings,
requires patience as well as expertise to use.
Because egg yolk is the binder for the dry
pigments, the paint dries quickly and cannot
be reworked. Brush strokes are not overlapped;
close values in each color must be mixed
and used to get modulation of tone. The
reward comes in the lustrous, rich surface
and the delicacy of the drawing and painting.
Haley looks on tempera as one of the tools of her
profession, which, she says, "When you know
them well, they give you the ability to do what
you want."

# SALLY
## Haley

*egg tempera painting*

The connection that can be seen in Haley's
work to 17th- century Dutch still lifes is in no
way an attempt toward re-creation. The
elaborate compositions, religious references and
dramatic lighting of the Dutch pictures are total-
ly absent in her acrylic paintings. It is the
geometrical austerity of her compositions that
marks them as modern. Many are a combination
of abstraction and representational painting in
which the background may be divided into ar-
bitrary rectangular color areas, or it may
represent the fold marks in a tablecloth or rows
of tiles, both of which act as subtle grids that are
a foil for the organic shapes placed upon them.
The isolation of the subject also is a modern ploy
and contrasts with the traditional practice of in-
cluding many related objects. Rather than being
part of a setting, Haley's subjects have a sin-
gular presence, and while they may hint at
metaphoric meaning, the artist does not provide
clues in titles.

All her works are untitled because, she said,
"Titles are redundant. The visual response is
what is important. I hope that my paintings are
contemplative and that they induce a certain
tranquility — but that is up to the viewer."

Photo: D. Thornton/Text: L. Allan

# *JANICE* Scroggins

## *musical composition arranging / performing*

*"My music is a story about myself, and nobody can tell the story about me like I can."*

Music is the power that runs Janice Scroggins' life: it is her work, her play, her therapy, her inspiration, her connection to the rest of the universe. It is a power she compares to a life force.

"Music to me is as essential as breathing or eating; it nourishes the spirit and makes everything harmonize. Music has led me to so many different books and ideas and people. It's helped me to pass through some very hard places and also helped me to let go of attitudes and beliefs that did not help me.

"There are so many emotions in music. I use my music to look at all aspects of my life: what kind of relationships to get rid of, what things don't belong in my life, why I'm doing what I'm doing — it's therapy."

Growing up in a musical family in Oakland, California, Scroggins sang and played at an early age: her mother and grandmother were her first teachers. From the moment she first heard the Modern Jazz Quartet, she knew that she wanted music to be in her life.

She is a multi-faceted composer/arranger/performer: she performs with jazz and blues musicians, Curtis Salgado and Norman Sylvester, and is working on a music video, producing Sylvester's forthcoming album, preparing her own album of original material, and recording and providing musical direction for the Interstate Firehouse Cultural Center's production of *The Colored Museum*, a sharp, satirical comedy about the black experience in America.

Scroggins speaks often about healing experiences, about the importance of one's work and the value attached to honoring one's creative life.

"You need to clear out the needless things and concentrate on what you really like to do — to get rid of excuses and put all your energy into causing the reaction you want to come about. It actually takes more energy to say you can't than to just do it, but first you need a process to let go of the worry, something to enable you to work." She credits Religious Science of Mind workshops for getting her "on course" and helping her establish priorities.

"It is so beneficial for both men and women to believe strongly in their work and to do it from the heart. Don't listen to those people who tell you that you can't — focus on what you want to do, show yourself that you belong there. Get it through your head that what you do is very necessary and that you belong.

"It would be great if more women would come out and feel free to do their work because your work is telling a story. My music is a story about myself, and nobody can tell the story about me like I can. So come and tell your story — it's a healing art and one we can all learn from. We all have the power to create: it's amazing the power we have by what we focus on, speak about, wish for."

Photo: C. Borland/Text: M. Lowry

# FAYE
# Cummings

## acrylic/collage

"The wonder of being an artist is that you can draw from a repertoire of fantasy."

Faye Cummings speaks with ardor about her art. Her work itself burns with passion.

Two monumental series are her major works, each dealing with social commentary. *Women at Work: A Creative Project*, 1986, was completed as her master of science graduate project at Southern Oregon State College. *Headlines: A Visual/Poetic Interdisciplinary Project*, 1988, was a solo exhibition at SOSC. The large canvases produce an effect that is vivid and cerebral.

*Women at Work* celebrates a day care worker, a nurse, a laboratory technician, an agricultural worker, a babysitter, a weaver, a retail salesperson and a clerical worker. The characters she depicts in acrylic/collage are archetypes we can all understand. Each woman speaks visually and through poems Cummings has written to accompany each of her paintings. Artemis, the clerical worker, says:

"God Jr. just buzzed me
On the interoffice phone
Wants a newspaper and a Pepsi
And this report by one."

Cummings' characters do not buckle under to the patriarchal system. Rather, they rally and take a stand. Artemis says at the end of her poem:

"Asked him what was wrong with his legs
Told him the report could wait
Told him I was gone for the day
Tomorrow I'll call in great."

In *Headlines* Cummings expands her materials into mixed-media collage, incorporating fabric, paper and acrylic paint on canvas. The textures surround the central figures with multi-level impressions that draw a viewer into the theme. To explore significant social issues, Cummings focuses on the dualities of themes, such as technology/nature, poverty/affluence, illness/health, masculine/feminine values and nationalism/global unity.

The end result is not at all what she imagined when she began, she says. "It's more subjective, inconsistent, darker and, possibly, better."

One of the series, *Nationalism/Global Unity*, creates a searing impact with its depiction of a young child, wide-eyed and gripped with fear. Nevertheless, the child still holds tightly an even younger sibling. In its strength it is reminiscent of the Diego Rivera murals of the 1930s.

Commercial success has eluded Cummings; as an artist, she is not alone. But a supportive companion and her own faith in her work support her ego, while her material needs are met by her work as a teacher of art and English and occasional sales of paintings.

Her painting and writing emerge out of a deep urgency to express concern and celebrate form. "Art and activism need not be mutually exclusive," she says.

The subjects in *Women at Work* are composites, drawn from a variety of places, amalgamations of people in her family. "The wonder of being an artist is that you can draw from a repertoire of fantasy. *Artemis Rising* is the closest to being autobiographical, of me being in a pink-collar prison, rootbound and knowing it ... reminds me of ancient 'girls,' of women in their '50s and '60s who have served men all their lives, who know how to tap dance ... but who are intelligent women..." she says.

In *Artemis Rising* she uses the poem to express her anger and yet moves into a creative mood: "think I'll start my own practice and blaze an artful trail, teach young women and old girls to cope with good old boys and the new male..."

Photo: H. Motley/Text: J.F. Anderson

# CHRISTINE
## Bourdette

*sculpting*

*"It's important not to be predictable."*

If Christine Bourdette had not been an artist, perhaps she might have been an orthopedic surgeon. Her studio is littered with bodies; her instruments — hammers, saws, drills and chisels — are neatly laid out as if for surgery. But unlike a surgeon, she doesn't just repair, she creates. And the bodies in question are created from her own visions of the human image and condition.

Intricately constructed as a tailored suit, Bourdette's figures of closely-woven wire mesh are more like skins than suits of armor. Standing upon large, splayed feet, her male, female and androgynous creations are as diverse as the human race, possessing a quirky humanity. Other figures, based less on anatomy than on the characteristics of the material used, evoke images of voodoo figures, Indian totems or effigies.

Working with these forms in a variety of materials produces very different results: some of the wire figures are left bare, some covered with plaster and pigment, others with leather and rawhide. Some offer only the barest sketch of a human figure, with skeletons created from driftwood and plate-like slabs of tin.

In the series of figures called *Squatting Melissas* (so named in honor of the friend who posed for them), Bourdette explored the body language of women in Eastern cultures, creating appealing yet slightly unsettling humanoid figures of wire, plaster and unfinished wood.

One of Bourdette's most popular public art projects was the collection of "moss people" she created for Portland's 1988 Artquake. Formally named *The Terrestrials*, these life-size figures were covered with sphagnum moss and posed on a downtown street corner. The Sasquatch-like creatures were a great favorite with passers-by, recalls Bourdette, who eavesdropped as she misted the moss people each day.

"Irony appeals to me. I like to observe people, their behavior and interaction. And people al-ways look for themselves in each piece, to try to see themselves in it in some way. Everyone wants to find something he or she can relate to."

Although *The Terrestrials* were temporary art forms and were dismantled after the display, their spirits were reincarnated this year during the Festival of Flowers at Pioneer Courthouse Square. "Heroic sculptures," Bourdette's term for three figures of gardeners made from strong wire mesh, were posed among the thousands of blooms in the square; flowers filled the crowns of their hats, creating a kind of high-tech topiary.

Bourdette's work continues to evolve, lately changing direction from sculpture to drawing. Working on paper allows her to escape the limitations of three-dimensional construction and to defy gravity, but her love of the human form is constant. "It's important not to be predictable" is the way she puts it.

"I want my art to be about life, not about art. And I guess that's why I've come around to working with images of the human body — because, after all, that's where everything begins."

Photo: D. Browne/Text: M. Lowry

*Round and Round*

# LAURA
# Ross-Paul

## *watercolor painting*

Glowing colors emanate a strange, unnatural light that silhouettes the two figures in *Round and Round,* as in many of Laura Ross-Paul's paintings. Her primary theme is the search for psychological wholeness, and these two, undifferentiated humans, isolated in their little boat, can be interpreted as two aspects of the self, one examining the other, as they affect, and are affected by, the forces of life. "For me, painting is a process of self-exploration," the artist says. "It comes from all aspects of my experience and is an attempt to externalize internal moments. Sometimes a feeling or a problem or conflict becomes clearer in my visual language than in my verbal language."

Her expressionistic style, which includes vivid colors carrying emotional impact, forms that are suggested rather than detailed, and brush strokes so charged with direction that they seem to have a will of their own, reflects the flux, the ever-flowing, changing psychic life of all humans. The figures are deliberately

androgynous because the emphasis is on universality.

Nevertheless, Ross-Paul realizes that hers is a feminine perspective, in which her experience as daughter, sister, wife, mother and professional artist all have a bearing. A particular empathy for women is apparent in an ongoing series of watercolor portraits, almost all of which are of the same red-haired model. She believes that the long-term interaction between the model and herself creates an ambience of trust and comfort that carries over into the paintings.

"I'm looking for the soul behind the face," she said, "not the woman-as-desirable-object image that has dominated so much of art about women by men."

The romantic notion of the artist as an uncouth neurotic is thoroughly contradicted by Ross-Paul in life as in art. Her studio is the upper floor of her home, an old house in Portland overflowing with the activities of her young children and husband, with art, books and toys, all of which — plus volunteer work as an arts advocate — are integrated into a daily schedule of work.

She is a native Oregonian and relates that her first big *job* was the painting of two 20-foot murals for her school when she was in the eighth grade. When asked how early she realized that she wanted to be an artist, she replied that from early childhood drawing was an important part of her life. "But I never thought of it as a career. It was the best way I had to communicate. Even now, I'm amazed that I can get paid for doing what I love to do." She does not regard her work as something separate from her personal life but rather as but one component, albeit a necessary one, for a complete and satisfying life.

Photo: T. Hendrix/Text: L. Allan

# PATTI McCoy

## *composing*

In the spring Patti McCoy will be playing a West Coast tour with Marian McPartland. In the fall she's sending two of her sons off to college.

"I've lived so many different lives," she says, as the boys — scooping up tapes, compact discs, bits of furnishings — sweep through the family music room. Past the bust of Chopin in the bookcase. Past the K. Kawai piano with an open copy of *Do Your Own Thing: A Step-by-Step Entry into Jazz Improvisation for the Pianist* by Patti McCoy. Past a framed album cover from the '50s, *This Is Pat Moran*, showing a pair of sexy ankles and red spike heels crossed on a keyboard. And another album cover, from the '80s, *Shakin' Loose with Mother Goose: Read, Rap, and Sing Along*, with Steve Allen and Jayne Meadows, music composed and performed by Patti McCoy.

"My whole career has evolved," she continues, recalling Helen Marie Mudget from Enid, Oklahoma, who trained in New York and at the conservatory in Cincinnati to become a classical pianist, until she heard jazz for the first time. "I had always played by ear. I didn't understand jazz, but it was exciting and it was what I wanted to play. Jazz has the same harmony and theory as classical music, but it has the element of freedom to express and improvise."

So Pat Moran began playing jazz piano in bars and getting fired for being too artistic. She formed a quartet and moved on to some of the better clubs, the Streamliner and Birdland, playing with the best, Duke Ellington and Earl "Fatha" Hines. The years of clubs and touring were frantic and good at first, then became lonely and hard.

In a casual collage of photos on a bulletin board in her music room, there's a black and white shot from 1959 of McCoy under a marquee ("Dinner-Supper/Jeri Winters/Pat Moran") bending over son Sean in his stroller. "Sean's first words were 'Thelonius Monk.' He was being raised by jazz musicians." She married Mike McCoy and retired to the Rogue Valley to have more babies and raise them as a family.

"I took 15 years to be totally with my five children. Since I was tied down, I had to find other areas of music to develop and ended up finding parts of myself." She began playing classical music again and started teaching. She learned to write jingles for Mike's advertising agency and began composing. She joined a church where she played gospel songs and found a spirituality that got her out of herself and created a new connection with her audience.

"It wasn't what I was playing. It was the spirit with which I was playing and the spirit with which they were receiving." Her spirituality and the security and love of her family have matured her as an artist, McCoy says. "When you play, first of all you have to make sure that all

> *"Since I was tied down, I had to find other areas of music to develop and ended up finding parts of myself."*

the physical things are prepared: your hands; then your mind is prepared: concentration; then, from there, you go into your spirit; it just flows from there. When you're at your best, you're free in your spirit and one with your music."

Patti McCoy's music now includes composing and arranging a new series of children's tapes in collaboration with her husband and two of her sons, following a successful series of children's albums with poet, David Zaslow, which she composed, arranged and recorded. McCoy likes to work at home in the Rogue Valley, especially with her family, and she feels ready to go on tour again. Her tour with McPartland came out of a program they recorded for National Public Radio. "My career is just now starting. Now I have everything — love *and* music."

Photo: H. Motley/Text: G. Sage

"Art needs to be a part of life as a whole, not a separate experience."

# ANNE
## Storrs
### *ceramic tiles*

The idea that art must be serious to be considered good is not one to which Anne Storrs subscribes. The Portland ceramic artist works in tile, clay and humor, fashioning homely subjects such as animals, food and even people's noses into gentle social comment. "I like working with tiles because they're like little sketches. You can put some humor in them, like in a little cartoon."

Her witty ceramics often feature prosaic images with a humorous twist: the decorative tiles she created for the restrooms of the Hult Center in Eugene capture whimsical scenes of people in various stages of preparation (men straightening their ties in the men's room, women putting on lipstick in the women's.)

A recent series of her pieces shows sculpted faces surrounded by illustrative tiles: a sleeping woman encircled by blue skies, clouds and a tiny flying woman-figure; a bemused man with some laughable and lifelike bugs; a hopeful reader of the personal ads ("Single White Female") and the men of her dreams; a self-portrait of Storrs surrounded by root vegetables.

"I always try to include one piece that makes a bit of an autobiographical statement. I called that one *The Studio's in the Basement* because at times I feel like a radish or a leek — most of my working life is spent underground, like a vegetable!"

The basement of her Westmoreland home is indeed a subterranean root cellar full of materials, projects and ideas. She is currently at work on a pediment for Gregory Heights Middle School in Portland. It will combine a large central motif of a trillium, done in mosaic, with a carved sequence showing the opening of the flower.

"I used the trillium image as a metaphor for my feelings about how children should be treated: gently, carefully and with respect, like fragile trillium flowers."

Storrs' largest and most accessible work is the entrance wall at the Oregon State Fairgrounds in Salem. The accordion-like structure is set with 24 tiles, which are arranged in a quilt design, illustrating scenes of the fair. Animals, fairgoers, vegetables and even a pie and some canned goods figure in this tribute to the state fair. Benches that are incorporated into the structure make this artwork an approachable and functional piece.

Storrs has great enthusiasm for Oregon's 1 Percent for Art program, in which 1 percent of construction and remodeling funds for state projects is set aside for public art.

"I'm interested in doing the kind of work that is accessible and that people can relate to and enjoy. Art needs to be a part of life as a whole, not a separate experience."

Photo: D. Browne/Text: M. Lowry

# BLACKSTAR
## WhiteWolf

*silversmithing*

" ...the eagle has seen the face of the World Maker and can carry our voices much further than we can."

In her presence, one feels a sense of harmony infused with patience. For her themes, she reaches into the history and spiritual traditions of her people. Always the eagle feather — a symbol of the human need for spirituality — is welded into her designs. After more than 50 years as a silversmith, BlackStar has created more than a million silver eagle feathers.

Other human needs are crafted into her designs — raindrops, a leaf, a flower, a ribbon of silver representing the trail of life — and the ever-recurring eagle feather.

In the tradition of her people, prayers are carried on the wings of the eagle, "because the eagle has seen the face of the World Maker and can carry our voices much further than we can," she says.

BlackStar, of Lakota-Sioux and Comanche lineage, was taught the religion and ways of the Comanche as a child in western Texas and Oklahoma. When only six or seven, Toah'Asa WhiteWolf (BlackStar) recalls pestering her silversmith uncle to use his tools and learn his art. Joining the women in their beadwork did not interest her.

Each of her originally designed pieces tells a story of a legend or a religious ceremony. All the patterns of nature and of life are in her designs of rings, pendants, belts, bracelets, earrings or hair ornaments.

Her love for and need of designing silver symbols extends into her personal life. Walking, reading, going into the mountains and serving her people's spiritual needs take her beyond her studio and workbench. "I do all of the living and dying ceremonies for the Indian people who do not have a spiritual leader in their community," she explains.

In her book, *Told in a Tipi*, BlackStar relates in poetry and prose the legends of her people. And these are the same traditions she has translated over a lifetime into a silver art form. At 68, she has no intention of retiring. Her son works with her on his designs. And her granddaughter, now only two and playing around BlackStar's workbench, is next in line to carry on the family's silversmithing tradition.

Photo: H. Motley/Text: J.F. Anderson

# MARY
## Oslund Van Liew

*dance/choreography*

Layers of the set peel away as the circus carries the audience deeper and deeper into a personal journey. It's a world where trick riders perform perfect leaps in the outer layers ... wire walkers strive for flight and balance ... the fiery animal tamer becomes the sensuous animal ... earthly clowns strive to adapt to new heights ... magicians transform themselves into the animated images of the film projected on stage ... and circus spirits bring enlightenment.

This is the circus of Mary Oslund Van Liew's collaborative dance production, *Oooh, Ahhh*. It's a circus that becomes a microcosm of a bigger structure and a macrocosm of a psychological internal structure "where all the oddities of the circus are within us."

She says a lot with her dance. But foremost, her works are high entertainment, integrating elements of modern dance, physical theater, contact improvisation and the personal contributions of the dancers.

Van Liew grew up in Eugene, where she first studied modern dance and ballet. She continued ballet at the University of Utah, then returned to modern dance, earning her master's degree in dance from Ohio State University. Recognized as one of the Northwest's most creative choreographers, Van Liew received both an Oregon Arts Commission individual artist fellowship and a choreographer's grant from the National Endowment for the Arts in 1988.

But like many female artists, Van Liew is more than artistic director of Oslund and Company/Dance. Van Liew also teaches dance at Lewis & Clark College and Body Moves. And she is the wife of Michael Van Liew and mother of two daughters, Liv, 14, and Corinna, three.

Mary and Mike make a point of hiring a baby sitter once a week so they can spend an evening together. "We don't have to do anything. We might go for a walk or drink a cup of tea. We've finally found a pattern that allows us to stay connected with each other, to access the love we have for each other and at the same time keep family and work going."

Family and work often mesh. Mike's music plays an important role in several Van Liew

*"You find more of your sense of being through movement than you do when you're sitting still, thinking about it."*

productions. And daughter Liv is the subject of a segment in *Entry*, another recent Van Liew production. "Liv burned her hand pretty badly when we were at the beach. It was her first experience with pain and how to deal with it." The result was a dance about events that change or shape people.

"I thought the piece was much too personal, and I was reticent to perform it. But the audience really responded to it. I learned I don't have to be too careful about putting personal material into a piece as long as the piece is open-ended and allows people to find what is universal."

To Van Liew, dance is not only a kinetic experience but a spiritual one.

"Dance connects you to the bigger whole. When you dance, you are essentially moving with the universe. You find more of your sense of being through movement than you do when you're sitting still, thinking about it. Artists connect people to the movement in their own souls. They connect people to a sense of vastness and to their own religious experiences.

"As a woman, I've experienced lots of things women experience, such as having children. I speak from the forum of a woman because I am a woman. But I'm more interested in personal issues and how they relate to the bigger picture. I want to reflect ideas that speak to more than one segment of society. I firmly believe — contrary to what some people say — that if the work is dynamic and has an essential quality to it, people will be interested in it, and it isn't hard to attract an audience."

Photo: C. Borland/Text: J. Kempe-Ware